Success
Strategies

in Art
& Design

Mary Stewart

THOMSON ™

WADSWORTH

Australia • Brazil • Canada • Mexico • Singapore • Spain
United Kingdom • United States

THOMSON

WADSWORTH

Dedicated to Heather Arak-Kanofsky and Nathan Kanofsky

Publisher: Clark Baxter
Acquisitions Editor: John R. Swanson
Assistant Editor: Anne Gittinger
Editorial Assistant: Allison Roper
Technology Project Manager: David Lionetti
Senior Marketing Manager: Mark Orr
Marketing Assistant: Alexandra Tran
Senior Marketing Communications Manager: Stacey Purviance
Project Manager, Editorial Production: Marti Paul
Creative Director: Rob Hugel
Art Director: Maria Epes

Print Buyer: Judy Inouye
Permissions Editor: Joohee Lee
Production Service: G&S Book Services
Text Designer: Tani Hasegawa
Art Editor: Maria Epes
Photo Researcher: Sue Howard
Copy Editor: Robin Gold
Illustrator: Jill Wolf, Buuji, Inc.
Cover Designer: Tani Hasegawa
Cover Printer: Courier Corporation/Stoughton
Compositor: Buuji, Inc.
Printer: Courier Corporation/Stoughton

Printed in the United States of America
1 2 3 4 5 6 7 10 09 08 07 06

Thomson Higher Education
10 Davis Drive
Belmont, CA 94002-3098
USA

Library of Congress Control Number: 2005936000

ISBN 0-495-00665-31

Interview transcripts are reprinted with permission.

For more information about our products, contact us at:
Thomson Learning Academic Resource Center
1-800-423-0563
For permission to use material from this text or product, submit a request online at
http://www.thomsonrights.com.
Any additional questions about permissions can be submitted by e-mail to **thomsonrights@thomson.com.**

Contents

About
the Author

Author Mary Stewart is currently the Foundations Program Coordinator for the School of Art at Northern Illinois University. Strongly committed to Foundations theory and practice, Stewart has taught beginning college students for more than 25 years and is the author of *Launching the Imagination: A Comprehensive Guide to Basic Design,* first published in 2002.

As an artist, Stewart is fascinated with relationships between knowledge and memory, as described in the dialogs of Plato. Learning Series, an installation of twelve 82" × 42" mixed medium drawings, is the most extensive result to date. She has received two grants from the Pennsylvania Council on the Arts and has participated in more than 80 exhibitions, nationally and internationally.

Courtesy of Mary Stewart

Preface

I have written this workbook in celebration of beginning students. Even after 25 years of teaching first-year and transfer students, I am always exhilarated by the ability, enthusiasm, dedication, and courage I see. Students who quickly adapt to college create remarkable work by the end of their first year and are already hot-wired for success when they enter their majors. Success in the major can then provide a springboard to professional success.

All art and design fields are highly competitive, however, and the demands of college coursework catch many beginners off guard. Time management has become increasingly important, as students more often have demands outside the classroom. Without additional guidance, even the most capable students often flounder in their first term and may drop out or change majors because of disorientation or burnout.

BOOK STRUCTURE

This book is designed to provide the guidance beginners need. The writing style is deliberately informal, and the projects are practical and concise. Workbook exercises are followed by "Success Strategies" checklists, and nine interviews with practicing artists and designers provide insight into the day-to-day realities of various professions. A special section on writing about art provides the bare-bones basics, and a series of essays about various majors provides an introduction to careers as well as to fields of study.

USING THIS BOOK

For your convenience, we have developed a simple fill-in-the-blanks workbook, with tear-out pages that can easily be submitted to your instructor for review. Although the number of projects is designed to match a standard semester structure, I expect that each user will adjust the order to best meet the needs of his or her specific class. Accordingly, each topic is presented as a self-contained unit.

ACKNOWLEDGMENTS

Finding just the right approach to this subject has been an interesting challenge. Any "how-to" college success book must balance informality with substance. A wonderful team of reviewers has helped enormously. I would like to thank Shaila Christofferson, West Virginia University; Cat Crotchett, Western Michigan University; William Dunn, formerly of Academy of Arts University; Jan Feldhausen, Milwaukee Institute of Art & Design; Anne Melanie, School of Art and Design, East Carolina University; Jean Miller, Towson University; Julia Morrisroe, University of Florida; Andrew Polk, University of Arizona; Gail Simpson, University of Wisconsin–Madison; Catherine Walker-Bailey, East Carolina University; Camden Whitehead, Virginia Commonwealth University; and Amy Youngs, Ohio State University.

I would also like to thank my own informal review team including Dr. Harold Kafer, Dan Dakotas, Pamela Allnut, Loretta Swanson, Mary Savaiano, Anthony Fontana, Tiffany Mason, Lydia King, John Regan, Cynthia Hellyer-Heinz, Christopher Wood, Dr. Mary Quinlan, Jennifer Bock-Nelson, and Amy Sacksteder. Research assistant Jessica Witte rough-drafted the sculpture essay in Unit 14, created the website list, and provided great support throughout. Michael Barnes helped with the printmaking essay, and each of my interview subjects offered writing advice as well as professional insight. I would like to thank Manuel Hernandez, Mary Ellen Munley, Jim Elniski, Andrea Grover, Keith Bringe, Heather Arak-Kanofsky and Nathan Kanofsky, Suny Monk, Amy Allen, Craig Pleasants, Sheila Pleasants, Pat Thomas, and Jeremy Shamrowicz and Steve Sorrentino from Flux Design.

I would especially like to thank Publisher Clark Baxter and Acquisitions Editor John Swanson for supporting this nontraditional textbook and Assistant Editor Anne Gittinger for her insight, patience, accessibility, and tenacity.

YOUR COMMENTS

I welcome both student and teacher feedback on this book. By better learning your needs, I can better develop subsequent editions. Please contact me at mstewart@niu.edu and check my website for further information and updates: marystewart.info.

Introduction

Entrepreneurs are initiates in the art of the possible, exemplars of persistence, lifelong learners who stop and see opportunities while others walk right by.

Gregory K. Erickson

This book is designed to help you understand college and adapt quickly. We will approach each step in the process as a component in your overall development as an artist, art historian, art educator, or designer. Major topics include the following:

▌ What general strategies for success do all college students need?

▌ What specific strategies for success do art and design students need?

▌ How can you find the major that best matches your aptitude and interests?

This book will require a high level of engagement on your part. Simply listening to me preach about time management, study skills, and portfolio preparation won't work. The choices are yours to make, and the sooner you take charge of the decision-making process, the better.

Let's start by considering the mind-set of the most optimistic and enthusiastic students. Like entrepreneurs in business, they are eager to explore ideas, create opportunities, and get involved.

THE ENTREPRENEURIAL SPIRIT

Developing an entrepreneurial attitude is the first step in building a career in the arts. Rather than waiting to be "discovered" or hoping to be appreciated, most successful artists and designers spend at least half their time visiting gal-

leries, contacting clients, and researching and writing grant applications. Four qualities are characteristic of entrepreneurs in art as well as in business: capacity for self-invention, vision, tenacity, and pragmatism.

Capacity for Self-Invention

Rather than adopting a fatalistic attitude and assuming that they have no control over events, self-inventors believe they can create their own future. They take responsibility for their actions and make deliberate choices that favor success.

Vision

Visionaries see opportunities where nonvisionaries see problems. Like medieval alchemists, they believe they can turn raw material into gold. In business, visionary entrepreneurs often seek failing companies or untested technologies. They realize that a great management team and an effective business plan can transform wreckage into wealth. In the arts, visionaries develop new techniques, invent new forms of expression, and develop new audiences.

Tenacity

Tenacity is the capacity to prevail, even when the situation seems impossible. All sorts of obstacles arise in any start-up business or new initiative. The first-time swimmer flounders; the first-time skateboarder flails and falls. Likewise, beginning artists generally discover more questions than answers the first time they use a computer program or draw a nude model. Those who give up easily drop out, regardless of their actual potential. Those with tenacity hang on and keep improving.

Pragmatism

Visionaries have their heads in the clouds, whereas pragmatists keep their feet on the ground. They balance big plans with basic practicality. They honestly assess their strengths and seek advice as necessary. Idea implementation requires a combination of vision and practicality.

 In the following interview, you will hear from printmakers Nathan Kanofsky and Heather Arak-Kanofsky and see the entrepreneurial spirit in action.

Success Strategies ▬▬▬

**HEATHER ARAK-KANOFSKY AND NATHAN KANOFSKY:
FROM COLLEGE TO CAREER**

▬▬▬

Heather Arak-Kanofsky and Nathan Kanofsky are master printers and co-proprietors of Arak Kanofsky Studios in Easton, Pennsylvania. The partners have distinct yet complementary skills. Heather focuses on managing the business and marketing the results. Nathan concentrates on production. He makes the plates from which the fine art prints are made, proofs and prints the editions, orders supplies, and supervises staff.

In addition to running the studio, Heather and Nathan have taught print-making workshops at Pyramid Atlantic, Manhattan Graphics Center, and the Metropolitan Museum of Art and at universities nationwide. In 1999, they wrote and published The Silicone Intaglio Workbook. *Since 2002, they have expanded their business to include work with hand-printed wedding announcements and portfolios.*

MS: The transition from college to professional practice can be difficult for art majors. The career path is rarely obvious, and it takes years for most artists or designers to establish their reputations and develop a solid source of income. You both received your BFA degrees from Syracuse University in 1992. By 1995, you had your own business up and running. How did you do it?

HA-K: We really began developing the business in the spring of 1991, a year before graduating from college. Inspired by my experience as a visiting student at the Central/St. Martin's School of Art in London, I decided to create a collaborative print portfolio as my honor's program thesis. This resulted in Portable Exhibition, a bound portfolio of 24 prints by 22 students at Syracuse University. Nathan became the primary production manager for this project, which was hand-printed in an edition of 122 books. I collaborated with Jennifer Morningstar, another printmaking student, on financing, managing, and publicizing the project. Through our work on Portable, we identified and developed our strengths and got a head start on our careers.

MS: What were the major obstacles, and how did you overcome them?

HA-K: In the beginning, all I wanted was to create a really great honor's project. With the help of my advisor, I explored various options. I finally realized that a collaborative compilation of artworks by my peers was the most challenging and exciting approach.

NK: Heather then "pitched" the idea to a group of around 20 seniors and Portable Exhibition was born. Participation was by personal choice, as an extracurricular activity. Heather was clearly onto something great, so I signed on right away.

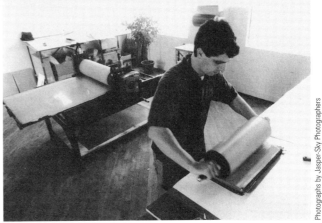

Heather Arak-Kanofsky and Nathan Kanofsky

Photographs by Jasper-Sky Photographers

As the team began to take shape, people volunteered to take charge of various aspects of the production, including developing the book design, raising money, and generating publicity. We had illustration majors, designers, and even a musician on the team. Little knowing how time-consuming it would be, I offered to oversee the printing.

HA-K: We followed up with weekly meetings, from October 1991 to February 1992. In the meetings, we set deadlines, discussed progress, and provided support to each other. Some of the meetings were intensely emotional, and I wondered if we would be able to continue. Because everyone was so committed to the project, we were finally able to work together despite the pressure, deadlines, and differences of opinion.

MS: Did it ever seem impossible?

HA-K: The biggest obstacle came at the very beginning of the project. We had to raise around $2,000 to provide the paper on which to print the images. We first tried to get support from the University. When that failed, we decided to pre-sell the books. Each of the 22 artists was required to pre-sell five books, at $25 each. At this point, all we really had was the idea for a book. We created a very professional promotional package, then sold Portable Exhibition to anyone we could find!

MS: I remember when you came to me with the subscription form, which I signed right away. The cost was manageable, and I was intrigued by the proposal and impressed by your ambition.

NK: The pre-sell process was essential. As soon as we raised the money, I put in a bulk order for paper and we were on our way.

MS: Once the project was complete, I understand that you had no difficulty selling the book, to both individuals and major libraries. Why was it so hard to sell at the beginning and so easy to sell in the end?

HA-K: Having a tangible result rather than a terrific idea made all the difference.

MS: How did Portable Exhibition help when you were job hunting?

NK: Portable Exhibition helped me secure a professional printshop internship at the end of my senior year. Robert Blackburn, founder and director of the Printmaking Workshop in Brooklyn, was impressed by Portable and offered me a job right away. I also began freelancing with international artists who stopped by the studio. This helped me further develop my skills and provided the professional contacts I needed when we started Arak Kanofsky Studios.

HA-K: Portable was a fantastic portfolio piece for me as well. I felt really confident about my work on the project and the skills I had gained. During an interview, I just connected these skills to the needs of my potential employer. I had an interview with Richard Minsky (founder of the Center for Book Arts in New York City) and he promptly hired me as an apprentice, at minimum wage. Within three months, I was program director at CBA, scheduling as many as 30 workshops a year.

MS: How does Portable Exhibition relate to the development of A-K Studios?

HA-K: In both cases, we really created something from nothing. We had to invent a product, raise the money, organize and motivate a team, meet deadlines, and market the results. The financial and management structure for A-K Studios is essentially the same, on a much larger scale.

NK: I learned how to break down a large project into smaller chunks, and learned to delegate. And, I learned a lot about collaboration. When I work with artists in the studio, it is my job to help them create the best print possible from their initial idea. My work on Portable Exhibition sure helped develop my diplomatic skills!

MS: What advice would you give to my students?

HA-K: First, learn creative visualization. If you visualize yourself succeeding, you can do amazing things. Second, remember that you can design your own learning process. Take charge of your education; challenge yourself! Keep in mind that you are pursuing a career, not simply amassing an impressive GPA.

NK: And, participate in your community, See what other people are doing and contribute whenever you can. You will learn a lot and can make the contacts that will come in handy later. Attend visiting artist lectures, so that you can find out how other artists and designers have created a career.

BUILDING THE LADDER

Visualize this.

As a first-year or as a transfer student, you are standing on your accomplishments to date. The set designs you created for the drama club, the crafts class you taught at a summer camp, your community college coursework—whatever you have done has gotten you to where you are now. If you've made it to college, you've already accomplished a lot.

Now, consider where you want to be in four years. What skills, knowledge, and experience do you need to begin your career in studio art, art history, art education, or design? There may be a big gap between where you are and where you want to go. And, very possibly, you see a lot of fog as you gaze into the distance.

To create a career in any field, you will have to build a ladder, step by step. The courses you take, the friendships you make, and the concerts or lectures you attend can all contribute to this process. Even your failures are important. One surprising characteristic of entrepreneurs is the ability to "fail fast." They take risks, learn from their mistakes, make adjustments, and move on to the next project. Just as you learn how to draw by drawing, so you will learn how to navigate college through your day-to-day experiences.

Most questions in this workbook are simple and direct—just fill in the blanks. Others require more thought and an extensive response, particularly for Units 5 and 15. Just expand your response by adding more pages of writing where necessary. The units will cover the following topics:

Unit 1: Getting Oriented. Who's who? What's what? This project focuses on basic navigation and exploration.

Ladder to success

Unit 2: Managing Time and Money. How can you best use basic resources?

Unit 3: Active Listening and Active Learning. How can you increase focus and retain what you learn?

Unit 4: Critiques: Giving and Getting Input. How can you make critiques productive and stimulating?

Unit 5: Making an Inventory. What knowledge and skills do you have? What knowledge and skills do you need?

Unit 6: Developing a Strategy: How can you use your resources to meet your needs?

Unit 7: Reading and Writing About Art. What are the essential questions? What skills and resources can you use to improve your writing?

Unit 8: Preparing a Portfolio. What are the purposes of a portfolio? What are the characteristics of a great portfolio?

Unit 9: Improving Your Performance. Clarify your goals and improve your grades.

Unit 10: Getting Advice. Who can help you plan your schedule of classes?

Unit 11: Creating Connections. How can you use information from one course to strengthen your performance in another?

Unit 12: Expanding Ideas. How can brainstorming and research feed your ideas?

Unit 13: Working Collaboratively. What are the challenges, dynamics, and benefits of working collaboratively?

Unit 14: Researching Your Major. What demands and what opportunities are presented by each major?

Unit 15: Self-Reflection. Review your accomplishments. What goals did you meet or exceed? How can you improve your performance next term?

Unit 16: Building Your Career. What opportunities do you want to pursue at the sophomore level and beyond?

In addition to the projects listed, at various points in this book you will encounter interviews with successful artists and designers. These "Success Strategies" interviews can help you understand the challenges and opportunities professionals have faced as they have built their careers.

GENERAL COLLEGE SUCCESS SKILLS

Briefly, any college student needs the following:

Ability to plan

▌ Determine how much you can reasonably accomplish.

▌ Set up a realistic schedule, balancing coursework, part-time job, and personal life.

▌ Anticipate and meet deadlines.

Willingness to become an active learner

▌ Attend every course regularly

▌ Consistently contribute to class discussions.

▮ Strengthen study habits and take notes.

▮ Learn from criticism and opposing viewpoints.

▮ Fully use learning resources, such as library, galleries, and museums.

Sense of community

▮ Meet other students in your program and in shared housing.

▮ Find a great mentor, counselor, or guide.

▮ Get involved in campus activities.

▮ Get involved in your local community or professional community.

Ability to set appropriate limits

▮ Determine how much rest and relaxation you need.

▮ Determine your noise tolerance and learn how to create quiet time.

▮ Learn how to be assertive yet tactful in social situations.

▮ Distill big ideas down to a manageable size without compromising their essential energy.

Why are these skills needed? Consider these differences between high school and college:

▮ College classes meet longer and class sizes are often much larger. It is easier to get lost in the crowd and may be harder to stay focused.

▮ High school teachers are primarily trained to teach. College teachers are primarily trained to do original research or creative activity. In college, you are likely to encounter unusual approaches to teaching and more difficult concepts.

▮ Tests occur less often in college, and few professors provide weekly grades. As a result, you must keep track of your own progress.

▮ High school classes are often "textbook focused," whereas college classes are generally "lecture focused." Thus, when you miss a class, you can't just read the book.

▮ Even when a textbook is required, the professors are less likely to test on every chapter assigned. You are expected to do the readings yourself and to incorporate the information into your class work.

▮ Learning facts is often emphasized in high school. Doing original research is emphasized in college. You will have to read more, analyze what you read, and write more extensively.

▮ College classes usually meet just two or three times a week. As a result, each absence has enormous impact.

▮ Essentially, in college, you have much more freedom *and* much more responsibility. Failure or success depends primarily on your actions rather than on the professor.

Success Strategies in Art and Design focuses on the particular needs of art and design majors. If you need help with college in general, check out the following books:

Arthur W. Chickering and Nancy K Schlossberg. *Getting the Most Out of College,* 2nd edition. Upper Saddle River, NJ: Prentice Hall, 2002.

David B. Ellis. *Becoming a Master Student with Discovery Wheel with Student Planner,* 10th edition. New York: Houghton Mifflin Company, 2002.

Howard W. Figler, Carol Carter, Joyce Bishop, and Sarah Lyman Kravits. *Keys to Liberal Arts Success.* Upper Saddle River, NJ: Prentice Hall, 2002.

John N. Gardner and A. Jerome Jewler. *Your College Experience: Strategies for Success.* Belmont, CA: Thomson Wadsworth, 2005.

Dianna L. Van Blerkom. *Orientation to College Learning,* 4th edition. Belmont, CA: Thomson Wadsworth, 2004.

UNIT 1

Getting Oriented

The real voyage of discovery consists not in seeking new land-scapes but in having new eyes.

Marcel Proust

Have you ever watched a cat or dog explore a new house? Many start by hiding under a couch. When the coast is clear, they begin to prowl around, exploring every nook and cranny. As soon as the animal understands its physical space, it ventures out and begins to behave more normally.

Humans also need orientation. Orientation creates a mental map or a conceptual framework. When placed within this framework, new experiences become exhilarating rather than overwhelming.

The following forms of orientation are especially valuable as you begin college:

▮ *Physical orientation* provides understanding of the size, location, and contents of various buildings on campus.

▮ *Academic orientation* gives you a better sense of program requirements, special opportunities, and connection between courses.

▮ *Social orientation* helps you understand community dynamics and develop friendships.

First, note some essentials:

New phone number _____ Your e-mail address _____

Courses	Teachers' names	Office hours	E-mail addresses
_____	_____	_____	_____
_____	_____	_____	_____

_____ _____ _____ _____

_____ _____ _____ _____

_____ _____ _____ _____

_____ _____ _____ _____

PHYSICAL ORIENTATION

What are the physical characteristics of your housing? Especially note the location of dorm exits and fire alarms.

Campus security phone Housing manager phone

_____ _____

What services are offered on campus and where are they located? Especially note the location and hours of the library, computer labs, art supply and hardware stores, copy center, health center, recreation center, post office, bank, and student union. Also note special resources, such as a writing center, Latino center, international programs office, and so forth.

Service	Location	Hours
_____	_____	_____
_____	_____	_____
_____	_____	_____
_____	_____	_____

If you have a car, get a parking pass as soon as possible, and determine which lots are most convenient. At large universities, art studios are often a mile from the main campus, so check out the bus schedules.

What special resources does the art program offer? Depending on the size of your school, you may find a visual resource center full of slides and art-related videos, an advising center, copier machines, computer labs, a woodshop, galleries, faculty offices, lecture halls, and various studios.

Art program resource	Location	Hours
_____	_____	_____
_____	_____	_____
_____	_____	_____

Most colleges have numerous opportunities for students, such as art exhibitions, special lectures by renowned experts, and concerts of various types. List three exhibitions, lectures, or concerts you want to attend this term.

Event	Venue	Date	Time
_____	_____	_____	_____
_____	_____	_____	_____
_____	_____	_____	_____

Most dorm rooms are pretty small. They are rarely designed to meet the needs of art students. So, find at least two places where you can work on large-scale or messy projects.

_____ _____

What and where are your primary sources for art supplies? It is a good idea to get the details now, rather than wait until you run out of materials the night before a project is due. List location, hours, phone numbers, and the kinds of stuff they sell. Hardware and stationery stores may offer basic materials at a lower price than art supply stores.

Store	Location	Phone	Hours
_____	_____	_____	____
_____	_____	_____	____
_____	_____	_____	____

Library Resources

What art and design information does the library offer? In addition to the books on art and design, look into magazines, reserve books, videos, and rare books or maps. You can use the library website for basic information, then visit the library in person for a more hands-on experience.

Primary floor and section for art books _____ photo books _____

design books _____

Note two terrific videos or DVDs in the library _____ _____

Note two terrific magazines in the library _____ _____

ACADEMIC ORIENTATION

To take full advantage of the programs offered at your institution, you need to identify its strengths. What are the strengths of your university or college? What are the strengths of the art program? Essentially, if you had to tell a friend why you chose your particular school, what would you say?

University or college strengths _____

Art program strengths _____

Many art and design programs are actually two-tiered. A "foundations" or "core" program dominates the first year. Work in a specific major begins in the second year. You are expected to transfer skills learned in the first year to your courses in the second year.

What foundations program skills do you most need to acquire? _____

If you are a transfer student and are proceeding directly into your major, are there any foundations course skills you still must acquire? For example, the foundations program at your new school may require students to understand basic computer graphics. If these skills were not required at your previous school, you will need to learn them on your own.

List skills you need to catch up or additional courses you will need to take _____

SOCIAL ORIENTATION

In addition to creating a sense of community and a personal safety net, your peers may become study partners or collaborators when you begin to build a career. List three potential collaborators, their interests, and contact information:

Possible collaborator	Shared interests	E-mail or phone number
_____	_____	_____
_____	_____	_____
_____	_____	_____

Most colleges and universities support arts organizations, hiking clubs, and Habitat for Humanity, just to name a few. If you can find and join an organization, you can broaden your interests and develop social skills in a supportive environment. Note several organizations of potential interest.

Organization	Meeting time/place	Contact person
_____	_____	_____
_____	_____	_____
_____	_____	_____
_____	_____	_____

UNIT 2

Managing Time and Money

The difference between stupidity and genius is that genius has its limits.

Albert Einstein

Most of us are not particularly organized when we enter college. Out of necessity, most who *remain* in college become quite well organized by the end of their first term.

Students in art and design need four types of organization:

- *Spatial organization.* Where can you do studio projects? Where can you store completed works and art supplies?

- *Energy organization.* Art and design courses are very labor-intensive. How can you keep that creative spark alive and avoid burnout?

- *Time management.* How can you meet deadlines without going crazy?

- *Money management.* Art supplies and textbooks are expensive. How can you maintain financial stability for the entire term?

The best approach to spatial and energy organization varies widely from person to person. A 30-year-old single parent living in an apartment has very different concerns than does an 18-year-old living in a dorm. Although specific needs vary, everyone can benefit from money and time management skills.

TIME MANAGEMENT

Time management increases the degree to which you control your academic life. You cannot increase the number of hours in a day, so using each hour well is the only way to cope with the college workload. If you have an additional commitment, such as a part-time job, time management becomes even more important.

The four essential aspects of time management are

▌ *First things first.* Meet major goals before moving on to minor tasks.

▌ *Step by step.* Many activities must be done in a specific order. Time management helps you plan the sequence and organize your resources.

▌ *Reality check.* You can't do everything at once. What activities need to be done later or deleted altogether?

▌ *Create balance.* You can't sustain creativity if you are frantic or exhausted. How can you best balance work and play?

Creating a realistic schedule is the key to all these aspects of time management.

STEP 1: **Schedule Overview** Using the following planner, map out your class and if necessary, your work schedule. Include time to work on homework and time for social activities. Here's an example:

	Sunday	Monday	Tuesday	Wednesday	Thursday	Friday	Saturday
6:00		Rowing team	Weight room	Rowing team	Weight room		
7:00							Outing Club Hike
8:00		2D Design	Drawing	2D Design	Drawing	2D Design	
9:00	Interfaith Service						
10:00		Clean up notes, check e-mail		2D notes, e-mail		2D notes, e-mail	
11:00	Art hist reading	Art hist class	Do reading for draw & 2D	Art hist class	Do reading for draw & 2D	Art hist class	
12:00		Lunch w/ study team	Writing class	Lunch w/ study team	Writing class	PM— clean room, wash, etc.	
1:00	2D Design assignments						Writing class assignments

Sample schedule overview

Now, here is a schedule for you to complete:

	Sunday	Monday	Tuesday	Wednesday	Thursday	Friday	Saturday
6:00							
7:00							
8:00							
9:00							
10:00							
11:00							
12:00							
1:00							
2:00							
3:00							
4:00							
5:00							
6:00							
7:00							
8:00							
9:00							
10:00							
11:00							

STEP 2: **Assignment Overview** Using a monthly planner, begin to map out your major assignments. As you become accustomed to the demands of college, start breaking down big assignments into smaller bits, giving yourself a series of small deadlines rather than one big deadline. Example:

	Monday	Tuesday	Wednesday	Thursday	Friday
Week 1	First day of class! Finish set-up; get parking pass, financial aid	Meet w/coach rowing team, 5–6, Rm 115	2D Design bio due— 2 pgs Get locker— office open 12–2	Drawing example due, quiz on Ch. 1	2D balance assign. due Art history vocab quiz! Read A.H. Ch. 2
	Read Ch. 1, 2D & Art History		Read Ch. 1, Anthro		
Week 2	→ Row—6–7 a.m. 2D—Revised balance project Read 2D, Ch. 2	Writing bio due connect to 2D bio Read Draw, Ch. 2	→ Row—6–7 a.m. *Bring Zip disc to 2D! Read Ch. 2, Anthro	Writing—bring notes on "Identity"	→ Row—6–7 a.m. 1–1:30—Writing Center—work on "Identity" outline
Week 3	→ Row—6–7 a.m. 2D Photoshop assign. #1 due Read 2D, Ch. 3	Wrt—Identity outline due	→ Row—6–7 a.m. 2D vocab quiz!	Wrt—identity revision due PM: Crank out very rough draft	→ Row—6–7 a.m. 1–1:45—Wrt Ctr Discuss "Identity" draft

STEP 3: **A Plan for the Day** As you start your day, check over your schedule and assignments. Then, rough out a plan for the day. Be realistic. Don't plan 12 hours of work down to the minute. Allow at least 15 minutes between activities. Example:

Daily Planner

Date (Mon) Tue Wed Thu Fri Sat Sun

Appointments
Time 6–7 Rowing team
8 2D Design—Be sure to bring black
9 construction paper & Xacto knife
10
11 Pay parking ticket & get pass *E-mail Art Hist. notes to Liz
12 Lunch w/study team—bring thumbnail sketches for 2D project
1 *Bookstore—get charcoal, etc.
2 SNOOZE!
3 Geology class & lab— bring topography assigment
4
5
6 Dinner w/Liz & Jamal

Daily Planner

Date (Mon) Tue Wed Thu Fri Sat Sun

✓	**To Do**	
Priority		Est. Time
3	Outline wrting paper on identity	2 hr
1	Pay parking ticket & ($20) get sticker! ($45)	45 min
4	e-mail Art Hist notes to Liz	
2	Get supplies for drawing charcoal	30 min
	kneaded eraser charcoal paper	

Keep the following five strategies in mind as you develop your personal schedule.

Seek Consistency and Balance

My boss is one of the most productive people I know. His approach to time management is based on consistency and balance. He arrives at and leaves work at about the same time each day and maintains a similar pattern of meetings each week. And, he carefully balances his administrative work with personal downtime. Rather than work constantly, he uses weekends for his studio work and fits in motorcycle rides whenever he can.

No one can or should work constantly. As a student, you are especially at risk of burnout. A methodical work pattern can help you create balance and reduces the time you spend deciding on what to do next.

Build in Flexibility

Because art and design are so engrossing, it is important to maintain some flexibility in any schedule you devise. That two-hour design project may actually need three hours of work. Breaking the creative flow midway is frustrating and counterproductive.

Find a Good Stopping Point

In general, major projects can't be done in one marathon work period. You will simply run out of physical and creative energy. Working beyond the limit is especially hazardous if you are using power tools. Taking a break can provide a fresh perspective as well as renewed energy.

Set an Early Due Date

The demands of college tend to be significantly greater than the demands of high school. A major project in high school may develop over an entire semester. In college, a comparable project may be due each month, in each class. And, if you are ambitious and inventive, you will almost certainly tackle several projects that require twice the amount of time you expect.

We often try to solve this problem by staying up all night to complete the work. One all-nighter a semester is not a major problem. Repeated all-nighters are exhausting, however. Attending classes when you are seriously sleep-deprived is torture!

Since you can't possibly predict the exact amount of time needed, it is wise to set a personal deadline two days before the actual due date. This will give you a bit of extra time if needed and can provide a moment of self-reflection before you bring the work to class.

Build in Breaks

A semester-long course is a marathon rather than a sprint. Pacing yourself is essential.

▌ Once every two hours or so, get up and stretch or take a ten-minute walk. This increases the flow of oxygen to your brain. Oxygen improves thinking.

▌ Once a day, assess your progress on a major project and plan the next step.

▌ Try to take one full day off a week. Getting away from a frustrating studio problem often helps artists and designers develop a fresh approach.

▌ Celebrate when you complete a major assignment. Rest (usually in the form of sleep) and relaxation (going to a party, taking a hike, having dinner with friends) are equally important.

MONEY MANAGEMENT

Tight finances are a fact of life for most art and design students. Basic tuition and housing costs are formidable, and the added cost of textbooks and lab fees can accumulate at an alarming rate. To top it off, art supplies are both a major expense and an absolute necessity. Trying to complete studio coursework without adequate supplies is an exercise in futility.

Money management can help you understand and balance your income and expenses. As with time management, we will focus on using limited resources well.

Create a Budget

A budget helps you identify sources of income, project likely expenses, and keep a tally of actual costs. Here's an example:

Budget for months _August to May_

Income Source	Anticipated Amount	Actual Amount
parents	$3000	$3000
Pell Grant	$5000	$5000
savings	$2000	$2000
sale of car	$1500	$1000
	Total: $11,500	Total: $11,000

Expenses	Anticipated Amount	Actual Amount
tuition and fees	$5000	$6000
housing & food	$5000	$5000
art supplies	$500	$1000
textbooks	$200	$400
travel	$300	$300
computer	$800	$2000
	Total: $11,800	Total: $12,900

Here is a worksheet for your own budget:

Budget for months _____

Income Source	Anticipated Amount	Actual Amount
_____	_____	_____
_____	_____	_____
_____	_____	_____
_____	_____	_____
_____	_____	_____
_____	_____	_____
_____	_____	_____
_____	_____	_____
	Total: _____	Total: _____

Expenses	Anticipated Amount	Actual Amount
_____	_____	_____
_____	_____	_____
_____	_____	_____
_____	_____	_____
_____	_____	_____
_____	_____	_____
_____	_____	_____
	Total: _____	Total: _____

Increasing Income

If your actual costs exceed your actual income, you will need to increase income, decrease expenses, or do both.

To increase income, consider these strategies:

▌ Get (or increase) financial aid.

▌ Get a job or add hours to an existing job.

▌ Get a scholarship.

▌ Freelance. Become a research assistant, sell your artwork, design T-shirts, or become a computer program tutor.

Each solution has advantages and disadvantages. Student loans are relatively easy to get, but they can really add up, resulting in a major debt load when you graduate. Part-time work can be equally costly because it may eat up the time

you need for your classes. Scholarships are wonderful, but there may be a significant lag time between entering a competition and receiving a check. So, as an art or design student, add the fourth possibility to your list. Many college teachers need help learning or using computer programs, and you may be able to supplement your income with periodic freelance work. Post notices on appropriate bulletin boards and ask your teachers if they know of anyone needing freelance help.

Decreasing Expenses

To decrease expenses, consider these strategies:

▮ *Seek alternative sources for supplies.* Try to get basic supplies from a hardware store or mail order company rather than buying everything at a more specialized art supply store. Check Internet sources for textbooks. Ask offset printing businesses for free paper.

▮ *Avoid buying on credit.* Credit card rates are often 15 percent or more, and late fees can be as high as $25 per month. If you get behind in your payments, a $100 art supply bill can increase to $115 because of the basic rate and, with the late fee, can balloon to $140. Worse, when using a credit card, it's easy to lose sight of your budget and start living way beyond your means.

▮ *Simplify.* Limit your wardrobe to a few basic colors and try to maximize use of any equipment you may have. For example, an iPod may serve as an external storage device for computer information as well as a personal music library.

Possible money-making strategies:

UNIT 3

Active Listening and Active Learning

In art, the hand can never execute anything higher than the heart can imagine.

Ralph Waldo Emerson

In general, college professors move at a brisk pace, often connecting many fragments of information together in one presentation. The sooner you can adapt to the pace and vocabulary used in college, the more you will enjoy the courses.

Note-taking is a major component of active listening. By taking notes, you can more fully follow the lecture from the beginning to the end. This helps you remain attentive and improves comprehension. By taking notes, you also tell the speaker that:

▮ I'm listening to you.

▮ You're saying something worth writing down.

▮ I'm ready to take responsibility for my actions.

When you take notes, focus on the major points rather than getting bogged down in minor details. Generally,

▮ Anything a professor writes on the board is important.

▮ Major headings in a visual presentation are important.

▮ The first 10 minutes of a lecture set the stage for everything else.

▮ Homework or readings are often assigned in the first or last 10 minutes of class.

If you find it difficult to identify the major points in a lecture class, ask the professor or teaching assistant for help.

NOTE-TAKING IN ART HISTORY

Art history note-taking can be a formidable task. The professor may present 60 or more images in a single lecture, and you may be expected to record the name, date, and artist, plus write comments on the style, subject, and content.

When the lecture deals with a single artist, you can use the approach shown here. List course date, title, and teacher at the top, then the name of the artist. It is a good idea to do a quick sketch of the image in one box and write comments in the other.

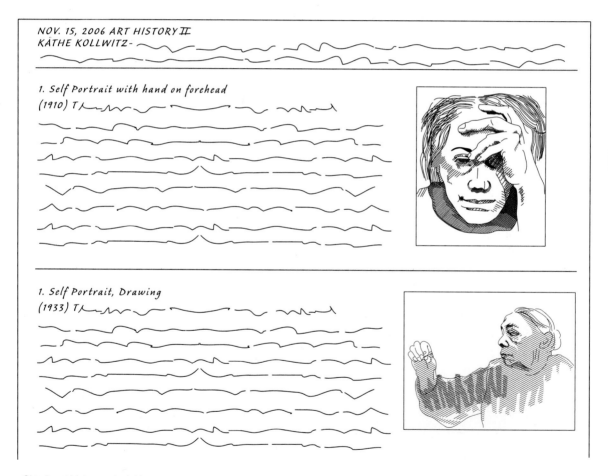

Simple art history note-taking

When a compare-and-contrast lecture is used, the professor will project two images simultaneously. Modify your approach, so that your notes match the following format.

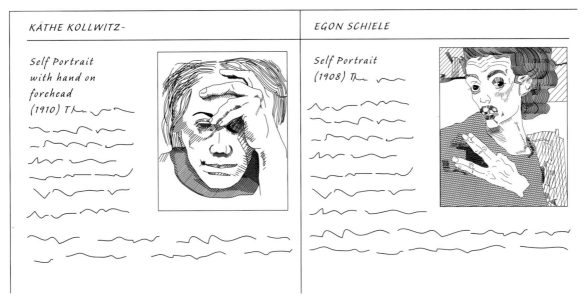

Compare-and-contrast art history note-taking

A lecture on an entire period (such as the Baroque), a distinctive style (such as Expressionism), or specific subject (such as self-portraiture) will require further modifications. Just try to combine visual and verbal notes whenever possible, and keep up with any textbook readings you are assigned. If the information is *really* unfamiliar, read the relevant art history chapter the night before the lecture. This will give you a broad overview of the topic before the professor even begins to speak!

STUDIO COURSE NOTE-TAKING

It is easy to overlook the value of note-taking in a studio course. Lectures tend to be informal, and in most cases, one-to-one coaching is the preferred form of communication. However, as with art history courses, note-taking in a studio can help you record course content, note due dates, and improve comprehension. Abbreviate, diagram, and condense information. Here's an example:

2D DESIGN, CLASS ONE

DESIGN = combo creative thinking & composition.
Design = "character of the organization of relationships" says Buckminster Fuller (designed geodesic dome.) how parts are connected more important the indiv parts.

Design #1: invent the widest variety of lines possible.
Explore relationship of lines to each other and relationship of lines to edges of paper.
Line = a point in motion, a connection between points, a collection of adjacent points. "The first line drawn is the fifth line in the composition." Closed compo is contained within format. Open compo appears to extend beyond format.

Design #2: create dynamic composition just using line.
(Static = at rest. Dynamic = moving or suggesting movement.)

chaos

composition

open composition

closed compo

static

dynamic

UNIT 4

Critiques: Giving and Getting Input

Creativity is more than just being different. Anybody can be plain weird; that's easy. What's hard is to be as simple as Bach. Making the simple, awesomely simple, that's creativity.

Charles Mingus

During a critique, the class discusses the projects presented and considers alternative solutions. When the discussion is substantial and supportive, everyone leaves with greater insight into the strengths and weaknesses of each artwork, and with a deeper understanding of the ideas behind the assignment. When the discussion is trivial or mean-spirited, motivation decreases, boredom increases, and the whole class suffers.

In general, critiques are most productive when

▮ The projects under discussion are well-developed and varied.

▮ The discussion is focused and purposeful.

▮ The opinions expressed are strongly based on the evidence presented.

▮ Recommendations for improvement are specific and supportive.

▮ Everyone contributes.

Personal responsibility is the key. Whether discussing a work in progress or a final project, the more you contribute, the more you will gain. Developing a solid understanding of the basic elements and principles of design is an essential first step. Line, shape, texture, value, and color are widely considered the most basic elements of two-dimensional design, whereas line, plane, space, texture, volume, and mass are often listed as the basic elements of three-dimensional design. The illusion of space and use of shading are especially

important aspects of drawing. Most professors will list unity and variety, emphasis and focal point, scale and proportion, balance, and rhythm as the essential principles of design.

If you are unfamiliar with this information, read a basic design textbook—several good options are listed in the Recommend Readings at the end of this book. You can then use your design vocabulary to back up each of your comments with specific examples. Rather than just saying, "Amy's composition looks great," you can say, "The use of diagonal lines and the illusion of space add energy to Amy's composition." By connecting a specific strategy (such as the use of diagonal lines) to a desired result (such as increasing compositional energy), you add weight to your words.

CONTRIBUTING TO A CRITIQUE

Before the critique even begins, look carefully at all the works presented. Select the three projects that seem to fulfill the assignment most effectively and note the specific strategies used. For example:

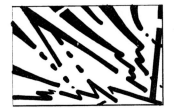

Amy's design

Antonio's design

Suh-Yi's design

▐ Amy's design has the most energy. She used jagged, diagonal lines and varied the weight of her lines. Lines intersect with the edge of paper and thus seem to explode right off the page.

▐ Antonio's design has greatest illusion of space. He put largest shapes in front, smallest in back, used overlap, and softened focus on background shapes. Central shapes seem to rotate, increasing compo energy.

▐ Suh-Yi's design uses focal point to increase unity. As a result, she was able to use nine different kinds of line effectively.

Then, select one of the less effective projects and consider strategies for improvement. Suggesting alternatives or ways to expand on existing strengths is more effective than bluntly telling another student what he or she "should do." For example:

Angel's design seems confused—lots of lines going in all directions.

▐ Try using a focal point or dominant direction to strengthen organization.

▐ Consider organizing the different types of lines into three separate layers, with the diagonals in red, horizontals in gray, and verticals in black.

▐ See what happens when your design is distilled down to just six lines.

Angel's initial design

Distilled design

Then, just wait for the professor to set the critique in motion. There are many possible approaches to critiques, so remain attentive and be supportive, no matter what. Listen to discussion of the works of others as carefully as you listen to the discussion of your own artwork. By looking carefully at all of the work and by jotting down some notes, you will be better prepared to contribute.

GAINING FROM A CRITIQUE

A substantial critique can be mentally and emotionally exhausting. Many different solutions may be presented, and you may get a lot of contradictory advice. In some cases, you will be asked to re-work your project after the critique. The following lists can help you determine additional actions to take.

Responding to a Recent Critique in a Drawing Class

Based on the critique of your work *and* the works of others, note the following:

Three ways to strengthen the idea:

Three ways to strengthen the composition:

Technical improvements needed:

Additional notes:

Responding to a Recent Critique in a Design Class

What is the strongest aspect of the design? _____

What is the weakest aspect of the design? _____

Should anything be added or expanded? _____

Should anything be deleted? _____

Should anything be repeated? _____

How can the project be strengthened conceptually? _____

How can the project be strengthened technically? _____

UNIT 5

Making an Inventory

The trouble with learning from experience is that you never graduate.

Doug Larson

At this point, you have probably completed a month of class. Review the material presented in each course, then assess the skills you have and the skills you must develop.

1. My greatest strengths in drawing are _____

For greater success in my drawing course, I need to learn _____

2. My greatest strengths in design are _____

For greater success in my design course, I need to learn _____

3. My computer skills include _____

I need to learn _____

4. My greatest strengths as a researcher/writer are _____

I need to work on these aspects of research and writing _____

5. I learn best and accomplish most when _____

Now consider where you want to be in four years. Where would you like to live? What do you want to have? Who do you want to become? What are your top priorities? What is your highest purpose in life?

This is not a "fill-in-the-blanks" type of question—just write as much or as little as you find useful. As Heather Arak-Kanofsky noted in the interview, visualizing success is the first step to achieving success, so think big!

You can use the following worksheet to get started:

Professionally, I want: _____

Personally, I want: _____

My highest purpose is: _____

UNIT 6

Developing
a Strategy

Another word for creativity is courage.

In this section, we will consider ways in which your resources can be best used to meet your needs. To accomplish this, you will need to develop a strategy, which is a deliberate plan of action.

Setting priorities is the first step in the process. There are two basic considerations as you establish your priorities. First, how *urgent* is the task? Paying your bills, getting a parking sticker, and buying the supplies needed for the next class are urgent: they must be done *now*. Second, how *important* is the task? Developing a great portfolio, improving your writing, and making lasting friendships are examples of important priorities.

Urgent tasks are best prioritized by deadlines. Simply writing them down and noting due dates will help you take care of these tasks. As noted in Unit 2 on time management, developing a weekly or daily checklist helps.

Your goals for college will help you determine the most *important* tasks. When making your inventory, you noted where you want to be in four years. That is a long-term goal. Now, be more specific. What do you want to accomplish *this* year? As you complete this section, note the following characteristics of good goals:

▌ *Honest.* Is it really something *you* want? Does the goal reflect *your* values?

▌ *Feasible.* Is the goal attainable in the time frame you have set? If not, expand the time frame or break down the goal into a series of steps.

▌ *Self-directed.* Rely on yourself. Rather than hoping that an instructor will give you a good grade, focus on mastering course skills yourself. You have a lot of control over your learning process, and strong artwork combined with substantial progress leads to good grades.

FROM INTENTION TO ACTION

Specificity is essential. By devising a clear course of action, you can move ahead purposefully rather than blundering around in the dark or waiting for someone else to act. Try creating a "top ten" list of specific actions you can take to improve performance in your most difficult course. For example:

Top Ten List of Ways to Improve My Drawing

1. Make 10 thumbnail sketches before starting each full-sized drawing.
2. Pay equal attention to the negative and positive shapes in the composition.
3. Lay out a rough gestural sketch of the whole composition before working up the details.
4. Use the edges of the composition very deliberately.
5. To check progress, step back from the drawing every 20 minutes or so.
6. If the proportions are off, erase and adjust, until I get it right.
7. Use shadows to increase the illusion of space.
8. When presented with a complex still life, choose an interesting section to draw rather than tackling the whole thing.
9. Use a wide range of values.
10. Look at both the subject and the drawing more closely.

Success Strategies

KEITH BRINGE:
ENTREPRENEURIAL ART HISTORIAN

Courtesy of Keith Bringe

Keith Bringe

Keith Bringe is the Executive Director of the Unity Temple Restoration Foundation (UTRF), a secular non-profit organization in charge of the preservation of architect Frank Lloyd Wright's first public masterpiece.

MS: How did you create a bridge between your undergraduate work and your career?

KB: I began work on a bachelor's degree in art history at the University of Illinois at Urbana in 1980. In my junior year, I got an internship at the World Heritage Museum, an "attic" museum collection including Greek and Roman artifacts that had been closed to the public for twenty-five years. It was a treasure trove of amazing objects, including an 18th-century plaster cast of the frieze that circled the upper exterior of the Parthenon.

The Parthenon, which is one of the masterpieces of world architecture, had suffered considerable damage

in the 1800s, so this cast of the undamaged artwork was especially valuable. I realized that we could make cast paper replicas from this frieze, and I helped fabricate and sell the results for $1,200 each. This provided seed money for other museum projects and also provided me with a job. My unpaid internship became a paid staff position, and I was launched into a career in arts management.

MS: Tell me about your current position.

KB: As Executive Director of the Unity Temple Restoration Foundation, I am primarily responsible for raising 12.5 million dollars and overseeing the restoration of Frank Lloyd Wright's first major public building, completed in 1905. Among the first buildings in the world to be constructed entirely from poured concrete, and in continuous service as a church, this architectural masterpiece is in serious need of help. The roof leaks, the heating system is 100 years old, the art glass needs cleaning and restoration. Money, expertise, and immediate action are essential.

MS: What strategies do you use in fundraising?

KB: There are six major themes in my administration and fundraising:

First, I must generate interest in the architectural restoration. The competition for donors is intense—they are solicited by many nonprofits. To gain support, I must convince them to put Unity Temple near the top of their giving priorities.

Second, I must establish credibility. Essentially, I am selling confidence in the UTRF mission and in my ability to effectively use donations to support that mission.

Third, I seek diverse sources of funding—everything from individual gifts and memberships to special events need to be included. No nonprofit should rely too heavily on a single source. If that income stream dries up, the organization will be in serious trouble.

Fourth, developing donor confidence is a gradual process. A $20 donation this year may lead to a two-thousand-dollar donation next year.

Fifth, funding organizations generally prefer collaborators to single-minded specialists. Community outreach is especially important. For example, the UTRF supports a concert series, programs for school groups, and tourism in the Oak Park area. When we develop programming like our recent "Wright in Japan Centennial Festival," we ask peer organizations to partner with us. It's good for them and for us.

Sixth, I actively publicize our successes as well as our needs. I can't raise money by selling the cracks in the concrete! Donors need to recognize the international significance of the building and know that their support really makes a difference.

MS: What advice would you like to give to my students?

Courtesy of Keith Bringe

Unity Temple interior

KB: I have several pieces of advice:

▎ View your mailing list as currency, and begin developing it as soon as possible.

▎ Learn how to write a compelling argument. Like an attorney or engineer, an artist must be able to communicate his or her ideas in a clear, concise form.

▎ Volunteer. Find the most interesting nonprofit in your community, and get to work. You will gain a lot of practical knowledge, and more importantly, can develop references that really distinguish you from others who have only focused on their GPA.

▎ Embrace marketing. Few galleries will seek an artist who lacks business savvy.

▎ Don't be afraid to ask for help. Start with advisors and guidance counselors. Ask them about grants, fellowships, and special programs you might attend. If you are running a nonprofit, ask leaders in the community for help. Attorneys and business people are often surprisingly generous with their advice. They may find their work with arts organizations to be more stimulating than their daily professional work.

▎ Be as gracious to the janitor as to the bank president. What goes around comes around and people talk!

MS: What is the most inspiring aspect of your job?

KB: I'm in love with the goal of restoring Frank Lloyd Wright's earliest masterpiece. I have a clear, quantifiable goal and can see improvements day by day.

UNIT 7

Reading and Writing About Art

The first act of writing is noticing.

A beginning writing course is required in most freshman programs. General writing skills (ranging from developing a thesis topic to completing an extended essay) are usually emphasized in beginning writing.

Art history courses require more specialized reading and writing skills. In essay tests, you may be asked to analyze an image compositionally or compare and contrast two paintings by different artists. Art history term papers require extensive research, solid historical analysis, and insightful interpretation of visual information.

Work your way through the following art history writing essentials, then if you need more information, read at least one of the books on writing listed in the Recommended Reading at the end of this book.

ART HISTORY WRITING ESSENTIALS

In many cases, you will be expected to write about the *form* (or overall structure of the artwork), the *subject* (such as the object, or event depicted), and the *content* (what it all means).

Common beginning writing assignments include the following:

▍ Simple description

▍ Formal analysis

▍ Compare and contrast

Concise examples of each of these three approaches follow. For the sake of simplicity, I will just write about two of my own artworks. They are part of a

Courtesy of Mary Stewart

Courtesy of Mary Stewart

Learning to Swim by Mary Stewart

Learning to Breathe by Mary Stewart

group of twelve 84 × 44" drawings, called "Learning Series," and were done using a combination of photography, drawing, and painting.

To start with a simple description, act like a reporter. Without making judgements, just decribe what you see.

> *Learning to Swim* is a tall vertical drawing that depicts a mysterious room interior. A dark, roughly rectangular shape dominates the bottom third of the drawing. A crowd of people in silhouette fills the center. The top third of the composition is dominated by a large target shape that is surrounded by clouds. The image is rendered in variations on dark brown and black.

Formal analysis lets you expand this simple description. You can now begin to analyze how the image was constructed, and the emotional effect that is created.

> The room interior seems enormous. Symmetrical balance provides compositional stability, while variations in scale and focus create the illusion of deep space. Four vertical lines accentuate the room's height, while the target shape acts as a focal

point, pushing outward while pulling our eyes upward. The crowds of people seem to be dissolving into infinity, especially at the misty center of the composition. The dark rectangular shape in the foreground deepens the mystery and enhances the illusion of space. It seems to be a platform, or diving board of some kind, positioned at a great distance above the crowds below.

In a compare-and-contrast essay, you will be asked to note the similarities and differences between two artworks. For example:

> Both *Learning to Swim* and *Learning to Breathe* combine symmetrical balance with an illusion of deep space. A circular shape provides a focal point in each drawing. However, the space in *Learning to Breathe* is much more agitated. A linear white rectangle separates the two layers of clouds, and each cloud layer seems to be moving in a different direction. *Learning to Swim* seems to pull us inward, while the space in *Learning to Breathe* seems to make us tumble from side to side.

In each type of essay, use specific examples to support your statements. Imagine that you are an attorney, arguing a case. Rather than saying, "My client is innocent" and hoping for the best, carefully build your case, substantiating your opinions with at least three specific examples or recommendations.

The following checklist can help to get you started:

▮ What is the subject? Has it been presented in a literal (or "realistic") way, or is it more abstract? Note that in *non-objective* or *decorative* artworks, there is no specific subject.

▮ What kinds of shapes were used, and why?

▮ Is the composition tightly contained within a boundary, or does it burst out, extending into the viewer's space? What is the effect of each approach?

▮ Is the composition spatially flat or spatially deep? How does the space affect the meaning?

▮ What is the dominant color scheme? How does color affect emotional impact?

▮ What materials were used, and how do they affect meaning?

▮ What is the intent? What ideas and emotions is the artist trying to communicate?

▮ Does the form effectively communicate the content?

WRITING FOR STUDIO COURSES

In your studio courses, you may be asked to write a biographical essay, an exhibition review, commentary on a visiting artist presentation, or a critique of your work or the work of one of your peers. In all cases, you must have something substantial to say and the ability to say it well. The same critique skills you learned in Unit 4 can help you develop something to say. You can then use the following strategy to improve your writing:

1. Write the sloppiest first draft possible, either writing by hand or on a computer. Just bang out your ideas quickly. Deliberately avoid re-reading paragraphs or trying to polish a sentence.

2. After a short break, write a second draft. Using the sloppy first draft as a beginning point, identify major points in your argument and add supporting information. Writing an outline can help you analyze the structure of your first draft and determine what areas need to be expanded or deleted.

3. Clean up the second draft using spell-check and looking for grammatical problems, then find someone to read your essay. If you are insecure about your writing, get help from an on-campus writing center or from a writing professor. Ask your reader to note strengths and weaknesses in the paper and suggest areas to expand, delete, or clarify.

4. Based on your reader's comments and your own insights, write the final draft. If appropriate, give the paper a memorable title. Make sure that each paragraph is clear and crisp. Generally, the first sentence presents the subject of the paragraph, the next two or three sentences elaborate and provide examples, and the final sentence offers an emphatic conclusion or a transition to the next paragraph.

5. A strong start and a strong finish will improve any paper, so make sure the first and last paragraphs are outstanding.

READING ABOUT ART

In addition to the reading you do for research projects, you can greatly benefit from four other written sources: course textbooks, books on creativity, websites, and art and design magazines.

Each type of reading can make a distinct contribution to your education. College teachers generally use textbooks to add structure and to elaborate on information presented in class. Books on creativity are inspirational and can be surprisingly informative. (A bibliography is provided at the end of this book.) Museum, gallery, and individual artist websites provide information on all kinds of exhibitions, and sites posted by professional organizations can provide information on careers. The website list at the end of this book can get you started.

Magazines are especially valuable. Most include four major types of information:

▍ Articles about contemporary art and design

▍ Interviews with artists and designers

▍ Exhibition reviews

▍ Listings of opportunities, including grants, residencies, and exhibitions

American Craft, Art in America, Communication Arts, Ceramics Monthly, Fiber Arts, and *Sculpture Magazine* are among the magazines most commonly provided by college and public libraries.

DEVELOPING YOUR WRITING

Just as you improve your drawing skills by drawing, so you can improve your writing skills by writing. Essays and term papers from your various classes are likely to keep you plenty busy. However, if you want additional practice, keep a personal journal or try any of the following creative writing exercises. In each case, see if you can tell a compelling story in 500 words or less. Practicing creative writing is especially useful if you are interested in becoming an animator.

Moment of Truth. Describe a pivotal event that changed your perspective on life.

Electric Word. Describe a word or phrase that triggers a strong emotional response for you whenever it is encountered.

Fill in the Blanks. Use one of the following phrases as the beginning point for a short essay: a. "The first time I _____." b. "I'm always apprehensive when _____." c. "The best gift I ever received was _____."

Success Strategies

AURORA PICTURE SHOW: MICROCINEMA MIRACLE

Aurora was founded in June 1998 by Andrea Grover and Patrick Walsh. Using volunteer labor and donated equipment, they converted a 1924 wooden church building into a 100-seat capacity microcinema. Aurora has now hosted more than 120 visiting artists and presented more than 3,000 films and videos. It has been featured on the Sundance channel and has recently received a major grant from the Warhol Foundation. I talked with artist and Aurora co-founder Andrea Grover about the importance of writing.

MS: What are the main forms of writing done by you and your colleagues?

AG: We write grant applications and follow-up reports, develop text for a quarterly calendar of events, correspond with artists and donors, and write press releases.

MS: Can you provide an example of each?

Andrea Grover

Courtesy of Andrea Grover

AG: Let's start with a grant application. In this excerpt from our Warhol application, we state our needs in the clearest way possible. An active voice is essential. Saying "we will" implement a new project is much stronger than saying "we would like to" do something. When we write a grant application, we are asking for financial and possibly administrative support. A concise, business-like approach is essential:

> . . . Aurora is actively exploring options for facilities expansion including participation in a centrally located, multipurpose arts complex with three other Houston arts organizations: DiverseWorks, Infernal Bridegroom Productions, and Suchu Dance. While our original theater will remain active, the new facility will house Aurora's offices, storage, and resource center (library, reading room, editing suites). The proposed facility will provide the needed square footage for Aurora's physical expansion, and benefit the organization through a major elevation of our profile, from a residentially scaled facility to an architecturally significant complex in an entertainment district . . .

MS: How about a press release? How is the writing similar to a grant application, and how is it different?

AG: A good press release provides the information news organizations need for their weekly arts calendar and, ideally, attracts critics and reporters to an Aurora show.

News organizations get dozens of press releases each week, as museums, artists, and galleries compete for publicity. We encapsulate the flavor of the event in the first three sentences, then follow up with a more extended description. We must get the reporter's attention right away, so a strong opening sentence is essential. Here's an excerpt:

> Aurora Picture Show is pleased to announce Media Archeology: Live Cinema, April 13–17, 2005. Aurora's second annual Media Archeology festival promises to be a spectacle of live film and video mixing, including looping, montaging, multiple projecting, and scoring before live audiences. The Live Cinema movement is the cinematic corollary of DJ-ing, sampling, and mash-ups, but rather than use music, these artists employ film, video and computer imagery as raw materials for audiovisual composition. . . .

MS: A calendar entry seems even more concise and enthusiastic.

AG: Yes. The calendars go directly to our audience. They are equally visual and verbal, and the text must be inviting and lively. As shown by the following example, we can be much more playful with calendar text:

> **Andy Mann Video Theater Revival, Curated by Andrea Grover and Jill Wood**
> From his Portapak-captured video verité of 1960s to 70s New York to moments of cable access brilliance here in Houston, Andy Mann (1947–2001) left an archive of over 800 videotapes to Aurora. In honor of Andy on what would have been his 58th birthday month, we invite you to celebrate one of Houston's most innovative and resourceful residents through a screening of rarely seen works.

MS: You were a member of the Portable Exhibition team described at the beginning of this book. What did you learn from that experience? Is there any connection to your current work?

AG: Portable Exhibition was a nonhierarchical collaboration—there was no project manager keeping everyone on task, no agendas, no minutes—and somehow everything went smoothly. Our approach to working together was very organic and somewhat unstructured. Perhaps we were successful because the group was small and self-motivated, and genuinely enjoyed each other's company.

However, my recent experiences have taught me that designated leadership, structure, goals, timelines, and deadlines are critical to successful collaborations, especially as the size of the group grows. This is not to say that you should not have a democracy when collaborating, but that you do need a structure to keep people motivated and on time.

I resisted formalizing anything about Aurora in the beginning, but now I realize that without systems and planning, organizations (and collaborations) cannot grow beyond a small and select community of enthusiasts.

UNIT 8

Preparing a Portfolio

Creativity is allowing yourself to make mistakes. Art is knowing which ones to keep.

Scott Adams

Typically, a course portfolio is a collection of eight or more artworks done by a single student. By presenting your artworks in a batch, you can demonstrate your technical breadth, the range of ideas you have explored, and the degree of improvement over a particular period. As a beginning student, you are likely to encounter three types: an entrance portfolio, various foundation course portfolios, and a major area portfolio. Each has a distinct purpose and specific criteria.

ENTRANCE PORTFOLIO

At many colleges and universities, the number of students seeking to study art and design greatly outnumbers the available openings. To admit the students with the greatest potential and motivation, many programs require an entrance portfolio as part of the overall college application.

Typically, this portfolio consists of 12 to 20 artworks in a variety of mediums. Each art school, college, or university is likely to have explicit guidelines for portfolio submission: get details from the programs of greatest interest to you. In all cases, select your artwork carefully. Drawings from direct observation are usually preferred over drawings from photographs, and anime-based cartoons or derivative images are often less convincing than works that are more personal. Torn edges or badly cut mats *will* be noticed by the reviewers who are usually artists and designers themselves, so good craft is essential.

FOUNDATIONS COURSE PORTFOLIO

The next type of portfolio generally appears in your foundations courses. Rather than grade each project one at a time, many professors will ask you to present a body of work several times a semester.

As with your entrance portfolio, thoughtful selection and good craft are essential. However, the course portfolio may be more cumulative and more process-oriented than the entrance portfolio. In a *cumulative portfolio,* you will be required to show examples of work from every single assignment. This type of portfolio provides a record of your overall development and reveals your weaknesses as well as your strengths. In a *process-oriented portfolio,* you will need to show your skill with developing ideas. A journal, thumbnail sketches, and preliminary studies are often included in a process-oriented portfolio.

Either type of portfolio gives you an opportunity to demonstrate your accomplishments visually. Review the requirements for each course, and build your case accordingly. If you review your notes from course critiques, you are likely to notice a pattern. During the first two months of class, most professors repeatedly emphasize three or four major ideas. Be sure that the works you select demonstrate mastery in these areas and showcase your personal skills.

Drawing Portfolio #1 Due _____

Must include the following artworks: _____

Objectives emphasized in critiques and class discussions: _____

Personal strengths I want to showcase: _____

Design Portfolio #1 Due _____

Must include the following artworks: _____

Objectives emphasized in critiques and class discussions: _____

Personal strengths I want to emphasize: _____

MAJOR AREA PORTFOLIO

In some colleges and schools, you will start out in a BA (Bachelor of Arts) pro-
gram, then apply to enter a studio-intensive BFA (Bachelor of Fine Arts) major.
Within the BFA, each major or concentration may have different portfolio
requirements. As with the college entrance portfolio, it is important to get the
portfolio details long before you actually present the work. If possible, get help
from an advisor as you construct this type of entrance portfolio.

Potential Major #1: _____

Number and type of artworks required: _____

Criteria for assessment: _____

Characteristics of successful portfolios:

For advice, talk to _____

Potential Major #2: _____

Number and type of artworks required: _____

Criteria for assessment: _____

Characteristics of successful portfolios:

For advice, talk to _____

Potential Major #3: _____

Number and type of artworks required: _____

Criteria for assessment: _____

Characteristics of successful portfolios:

For advice, talk to _____

UNIT 9

Improving Your Performance

If there is no wind, row.

Latin proverb

This workbook is designed as a celebration of your potential and a guide to improving your performance. Grades are the most clear-cut evidence of the results. If you have done all the workbook exercises, are attending class regularly, and doing lots of homework, yet are still getting low grades, a change is needed. If you simply lack sufficient aptitude or motivation to pursue a profession in the arts, you may need to change majors. However, if you have the aptitude and motivation, but seem out of sync with your art courses, start by analyzing your assignments.

UNDERSTANDING ASSESSMENT CRITERIA

On what basis will the professor be judging your performance? Let's analyze a sample assignment.

Line Dynamics

Problem: Create four black and white designs that demonstrate visual dynamism.

Objectives:

▎ To explore compositional movement

▎ To suggest an illusion of space

▎ To fully engage every square inch of the composition

Materials: Black felt markers and 18 × 24" drawing paper

Strategy: Use thumbnail sketches to rough draft at least 10 ideas.

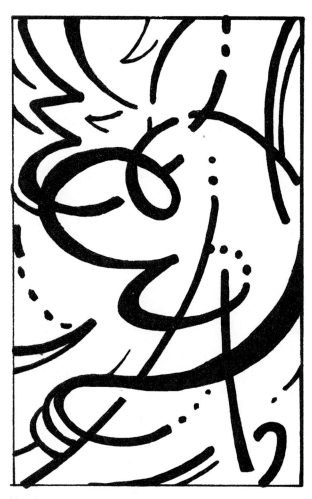

Line dynamics design sample

▌ Pay special attention to the edge of the composition. When a line or shape intersects this edge, the composition can visually extend beyond the page and into the viewer's world.

▌ Overlap, variations in size, location, and degrees of definition can be used to increase the illusion of space. Deeper space gives more room for movement. Movement can increase the overall energy in the design.

▌ Experiment with various forms of balance. Symmetrical balance is often used when stability is needed, whereas asymmetrical balance is generally more dynamic.

Assessment criteria:

▌ How strong is the sense of compositional movement?

▌ How deep is the space?

▌ Is every square inch of the composition used deliberately?

Note that the *objectives* and *assessment criteria* for the preceding assignment are essentially the same. Generally, the objectives will tell you the basis on which the work will be judged.

Visual examples clarify targets even more. Ask your professor to show examples of past students' work for the same assignment or to suggest artists and designers who have done work in a similar vein. Although you must develop your own response to the assignment, having an example can get you moving in the right direction. Essentially, an example helps you see the target. This is especially important if you have little prior experience in art and design.

EXTRA CREDIT WORK

If you want to learn to play the piano, you have to practice—a *lot*. Likewise, if you want to master drawing, you will have to draw—a *lot*. This is especially important if you have mostly worked digitally or photographically. Drawing includes a major translation of information from the visual world into a type of symbolic representation. If you haven't done this before, you will almost certainly make dreadful drawings for at least a month.

To keep from failing and to increase your self-motivation, check with the professor to see if you can do extra credit work or do each major assignment twice. Arranging a specific plan of action can be helpful, so that both of you understand what needs to be done, and why. This extra practice can speed up your learning process, and thus improve your performance.

UNIT 10

Getting Advice

A person who never made a mistake never tried anything new.

Albert Einstein

Academic complications tend to increase in direct proportion to the size of a school or college. So, if there are more than 200 students majoring in art and design at your institution, pay particular attention to the following information.

Essentially, most concentrations or majors present a menu of courses that you must complete. There is usually some overlap from major to major—everyone generally takes the same introductory art history classes, for example—and some substantial differences. For example, you will probably take a lot of figure drawing if you are majoring in painting and at least one typography course if you are studying graphic design.

So, you really need two pieces of information. First, what courses must be completed for your major, and second, in what sequence must they occur? In many cases, you must take a prerequisite (or introductory course) before you take a more advanced course, so sequencing can be crucial. The following page provides an example of the menu for a drawing major.

Generally, a senior faculty member or advisor can help you plan your schedule and may have to sign off on various bits of paperwork. Just remember that any advisor is likely to be meeting with *lots* of students, and some students will need a lot of help. Thus, your meeting with an advisor may be quite brief. Be prepared!

Four-Year Course Plan: BFA in Drawing

Semester 1
ART 100 – Basic Drawing 1
ART 102 – 2D Design
ARTH 110 – 20th C Art History
General Education _____
General Education _____

Semester 2
ART 101 – Basic Drawing 2
ART 103 – 3D Design
ART 104 – Time Design
General Education _____
General Education _____

Semester 3
ARTS 200 – Life Drawing 1
ARTS 210 – Painting 1
Studio Elective _____
ARTH 251 – Art History Survey 1
General Education _____

Semester 4
ARTS 202 – Anatomy
ARTS 220 – Printmaking 1
Studio Elective _____
ARTH 252 – Art History Survey 2
General Education _____

Semester 5
ARTS 305 – Life Drawing 2
ARTS 310 – Drawing Workshop
Studio Elective _____
ARTH 201 – Film History 1
General Education _____

Semester 6
ARTS 307 – Narrative Drawing
ARTS 312 – Materials and Methods
Studio Elective _____
ARTH 202 – Film History 2
General Education _____

Semester 7
ARTS 401 – Advanced Drawing 1
ARTS 411 – Kinetic Drawing
Studio Elective _____
Art History Elective _____
General Education _____

Semester 8
ARTS 402 – Advanced Drawing 2
ARTS 440 – Senior Project
ARTS 450 – Research Studio
Art History Elective _____
General Education _____

Sample menu of classes for undergraduate major

To ensure that *your* meeting is timely and productive, follow these steps:

1. Find out the best time in the semester to schedule an appointment. Don't wait until two days before you are scheduled to register for classes.

2. Look over the requirements for your major, and bring any questions you need to have answered. You are the person who will be most affected by a foul-up in your schedule, so learn as much as you can.

Also be aware of the following realities:

1. Many art classes have limited space and thus close very early in the registration process. Sign up for courses as soon as you can. In a semester system, registration generally begins in mid-October for spring semester classes and in mid-March for fall semester classes.

2. When planning your schedule, note courses that require permission. For example, at my university, students in visual communications classes must have a 3.0 GPA or higher from their foundations courses. As a result, they must get an additional bit of paperwork before they can register.

3. Each school, college, or department has its own registration details. Jot down details about your system, and get any handouts that may be available.

UNIT 11

Creating Connections

Creativity requires the courage to let go of certainties.

Erich Fromm

If you connect information from one course to another, you can build your skills more quickly and with less effort. You can't turn in the same assignment twice (that is academic misconduct, and can get you expelled), but you can and should use ideas from one class to support work in another. Look at your notes on the preceding pages. What compositional ideas from your design class can you use to improve your drawings? What drawing skills can you use to improve your designs? How can ideas from your art history lectures expand your creativity?

KEEPING A JOURNAL

Keeping a journal is a great way to create connections. In it, you can brainstorm new ideas; record your responses to lectures, exhibitions, and critiques; and analyze questions that arise. Many students record ideas at the end of each class, then review them at the beginning of the next session. Others write in their journals at the beginning or end of each week. In either case, keeping a journal tends to increase your self-awareness and improve your decision making.

The following questions may help you get started:

▌ What similarities were there among my studio courses this week?

▌ What similarities were there among my academic courses this week?

❚ Can any of the ideas from my academic courses help me solve a studio prob-
lem? Can a studio idea help me solve an academic problem?

❚ If I had no constraints in time or money, what would I *really* like to do for this
assignment?

 Viewing the journal as a record of your creative process is ideal. Don't cen-
sor; just draw and write freely. And be sure to record your impossible ideas—
the ones that are too big to construct in a dorm room or too complicated to
complete by the date due. Often, an idea today can help you solve another
problem tomorrow. In fact, it is wise to review the journal as you move into
upper-level classes. Ideas that are too ambitious or time-consuming for a first-
year course may be perfect in an upper-level course.

TAKING A MINOR

In conducting the interviews in this book, I was surprised to note how often
successful artists and designers combine multiple areas of study. For example,
museum consultant Mary Ellen Munley majored in psychology, whereas Jim
Elniski majored in art then added a degree in social work when he was in his
thirties. Later in the book, we will meet medical illustrator, Pat Thomas, who is
equally knowledgeable in art and science. And in the concluding interview,
Jeremy Shamrowicz from FluxDesign describes majoring in sculpture and
industrial design while minoring in illustration. I can only conclude that multi-
ple interests increase versatility. In a rapidly changing economic climate, versa-
tility seems to be a real strength.

Success Strategies

MARY ELLEN MUNLEY:
ENGAGING THE PUBLIC

Courtesy of Mary Ellen Munley

Mary Ellen Munley

*Mary Ellen Munley is principal of MEM and Associates, a
consulting firm in Chicago dedicated to enhancing the role
of museums in the lives of people and communities. She is a
recipient of the American Association of Museums award for
excellence in the practice of museum education and presi-
dent of the Visitor Studies Association.*

MS: Tell me about your work.

MM: I am a consultant, dedicated to developing a wide
range of museum-based education and outreach programs.
I help the museum staff reach answers to the following
questions:

❚ Who are your primary audiences?

❚ How can your museum best serve your audiences—what
programs and exhibitions will be more effective?

❚ Can workshops or lectures be used to attract new
audiences?

❚ How can program effectiveness be tested?

MS: How did you get into this field?

MM: In 1985, I took a year off from my job as a college psychology professor to study in an intensive museum education program at George Washington University. Within two weeks of my arrival, the Smithsonian Institution established its first audience evaluation office, and I was hired to develop evaluation tools and conduct observations and interviews in their nine museums. I was then asked to become the research coordinator for the Commission on Museums for the New Century. After writing a chapter on education for the final report, I was well on my way to a new career.

MS: Please describe one of your most exciting projects.

MM: Hmmm. Let me describe a project that really demonstrates the transformative effect a museum can have. As the new Chief of Museum Education of the New York State Museum in Albany, I had heard that low-income neighborhood kids often came into the museum after school, and tended to be disruptive. Sure enough, shortly thereafter, I was informed that the problem had gotten out of hand, and looking out the front door, saw the city police escort three kids out of the museum. The kids were 8, 11, and 13 years old.

I quickly scheduled a staff meeting. Initially, the kids were seen as the problem, but through discussion, we realized that lack of after-school activity was the real problem. They came to the museum because they didn't have anywhere else to go.

So, we started the Museum Club. It met in a little space behind one of the dioramas, which immediately gave the kids a sense of being insiders. Like the museum guards, the kids got ID badges to wear. The Club soon had over fifty members, most attending three or four days a week. When they arrived, they got a snack, were given time and space to do their school homework, then did a museum activity. For example, during a temporary exhibition on dinosaurs, working as a team, they constructed a giant papier-mâché dinosaur.

Within two months, the kids knew the guards and the guards knew the kids. When problems did arise, the Club coordinator acted as a liaison between the guards and the kids. The kids came to love the museum and began bringing their families to special programs and events.

What began as a problem was transformed into a solution. We expanded our audience and provided the kids with a supportive after-school program. This project captured the imagination of several funding agencies, and we soon built a clubhouse right in the middle of the main floor of the museum. Members of the Museum Club even helped curate one exhibition.

MS: What skills do my students need if they want to pursue museum work?

MM: There are four primary components to most museums: research, collections, exhibitions, and public projects and programming. And, there are a host of other jobs related to basic museum operations: budgets, fundraising, marketing, maintenance, and so forth. The following basic information should get your students started:

❚ Everyone working in collections, research, exhibitions, and public programs needs broad knowledge of the content area the museum represents. For the

Guggenheim Museum, a degree in art history is helpful; for the Museum of Natural History, you will need knowledge of anthropology, biology, or other sciences.

▌ In an art museum, understanding of various techniques and compositional strategies is important. School groups and adults alike are often interested in how artworks are actually made, so technical information is important.

▌ If you are working with the public, knowledge of human development and learning processes is most helpful. My background in psychology helps me craft appropriate experiences for a wide range of visitors.

▌ Finally, some business background is great to have. Funding is always a concern, and being able to manage a budget or write a grant will immediately strengthen your application.

MS: What is the best way to gain museum experience?

MM: There are a number of museum studies programs that offer great courses. Really, though, nothing beats hands-on experience. Being in the museum day in and day out, seeing the problems that arise and the solutions that are devised—that's the real education! So, I strongly recommend an internship, even on an unpaid basis.

MS: What do you most enjoy about your work?

MM: It is so varied and so valuable. A museum is an educational resource as well as an archive for the treasures of civilization. I love finding new ways to engage the public and encourage lifelong learning.

UNIT 12

Expanding Ideas

Anyone who works as hard as I can do as well.

J. S. Bach

As you move into the second half of the term, it is likely that studio assignments will become more idea based. The following methods can help you expand your ideas. If you need more help in this area, read Chapter 1 in Lauer and Pentak's *Design Basics,* Part 2 in Stewart's *Launching the Imagination,* or any of the idea generation books listed in the Recommended Readings.

WORDPLAY

Choose one keyword from the assignment title or description, and build as many branches as you can. Here's an example, using an assignment called *Concealing and Revealing.* First, look up the word *conceal* in a dictionary.

Conceal: To keep from being seen, found, observed, or discovered; hide.

Add ideas from a thesaurus:

Conceal: bury, cache, camouflage, cloak, cover, cover up, disguise, dissemble, enshroud, hide, harbor, keep secret, lie low, lurk, mask, masquerade, obscure, obstruct, plant, screen, secrete, shelter, shut out, skulk, sneak, stow, veil, wrap, screen, shroud.

And do a keyword search on the web or in a library catalog.

Then, create a "mind map," exploring as many ideas and implications as possible.

Sample mind map

Finally, visually play around with the word. Try to develop at least a dozen visual ideas that are related to the word, and complete at least 25 thumbnail sketches.

ANIMATED OBJECT

Choose any object—a piece of chalk, a clock, a coin, an accordion, a lipstick. As with the Wordplay assignment, generate at least a dozen variations on this single object. How is it most commonly used? Are there any emotions or ideas you associate with this object? For example, a teacher uses chalk to write on a blackboard; a child uses chalk to draw a hopscotch pattern on the sidewalk, a physicist uses chalk to develop a new theory, the police use chalk to mark the location of a murder. Now, imagine that you are making an animated film. Visualize the object morphing into a whole series of related shapes or ideas.

Sample animated object

FIND EXAMPLES

One of the best ways to get started is to see how other artists and designers have solved similar problems. Find examples in art history lectures, on the web, in books and magazines, during gallery visits and visiting artist lectures, and so on.

Problem you are seeking to solve: _____

Four examples from a design textbook:

1. _____

2. _____

3. _____

4. _____

Four examples from magazines:

1. _____

2. _____

3. _____

4. _____

Four examples from art history textbooks:

1. _____

2. _____

3. _____

4. _____

Four examples from movies or video:

1. _____

2. _____

3. _____

4. _____

Success Strategies ▬▬▬▬

JIM ELNISKI:
ART AS ACTION

▬▬▬▬

Jim Elniski is an artist, educator, and clinical social worker. His work with groups and communities employs a hybrid approach, linking individual and collective expressions of art making.

Courtesy of James Elniski

Jim Elniski

MS: When we define "art" or "artist," we usually think of objects. A painter makes paintings; a photographer makes photographs. You produce actions rather than objects. How did you get started, and what attracts you to this type of work?

JE: I grew up in a large working-class family, focused on day-to-day survival. I really had no exposure to "Art" with a capital A. So, working with direct experience rather than making a masterpiece for a museum really comes naturally.

A Fulbright residency in Nigeria heightened my interest in creating an action rather than building an object. During that time, a massive famine was unfolding in Africa, with thousands dying everyday. As I listened to news reports from the BBC, my studio practice began to seem rather self-indulgent.

So I began to think more about ways to explore the meaning of art in the world. I realized that I wasn't primarily an object maker, and thus needed another way to make a living. I returned to grad school for a Masters in Social Work, from which I have developed a small private practice.

MS: What criteria do you use in selecting an action to turn into an artwork?

JE: I look for anything that opens up the viewer to a re-consideration of reality. I want viewers to see something that was previously unseen. Power can be described as "the capacity to sustain relationships." I am interested in transitions and transformation, rather than stasis and solidity. The moment of change is more powerful than the "this" or "that."

MS: Please describe a project that went especially well.

JE: *Markers of Identity* (done in South Boston in 1987) worked especially well. It was sponsored by Very Special Arts, an organization that supports art activities for challenged populations—in this case, a group of boys, aged 10 to 12, many with ADD, who had been disruptive in class.

I noticed that the boys seemed obsessed with writing their names—the name was essential to their identity. So, I had them pick out a favorite letter from their name, abstract it, enlarge it, then draw it in chalk on the basketball court. The final "glyph" or icon was so big that the boy could sit inside, creating his own personal boundary.

Adding rocks to the artwork was the next step. Most of these kids had been bused into a South Boston neighborhood that was very hostile to them. People threw rocks over the schoolyard fence all the time. So, we collected the rocks, and used them to add visual impact to the personal glyphs. When people in the neighborhood realized that we were using their rocks to build our art, the number of attacks began to diminish.

MS: How can my students develop collaborative projects of this kind?

JE: As initiators of art actions, they should

▮ Write down the various communities of which they are members.

▮ Determine what the members of that community share—physically, emotionally, spatially, and culturally.

▮ Create an event that will help celebrate and strengthen shared qualities.

▮ Essentially, seek to reduce "us and them" thinking. Ultimately, we are all connected; we all share this human adventure.

MS: How do you define your role as an artist?

JE: I am both creator and catalyst. My special interest as an artist, educator, and psychotherapist is the dynamic nature of how we shape, and are shaped by, the world around us.

Markers of Identity

Courtesy of James Elniski

Use this space for your own mind map.

Use this space for your own animated object sketches.

UNIT 13

Working Collaboratively

When you're stuck with a tough decision or a problem you don't understand, talk to all the smart people you know.

David Kelley, Founder, IDEO

Teamwork helps distribute the workload, expand ideas, and create connections. In general, the following steps increase success when you work collaboratively:

1. Take time to clearly define the problem you are seeking to solve. Running 50 miles an hour in the wrong direction is just exhausting.

2. When brainstorming, use a positive and supportive attitude. Knee-jerk negativity immediately kills potential, whereas encouragement and optimism builds potential. Remember that the most innovative ideas rarely make much sense when they are first described. Build on the ideas your friends present rather than rejecting them out of hand.

3. Write down ideas as you go along. Even a very rough written record will help you compare and contrast the solutions proposed. Oversized Post-it® notes (18 × 24" or larger) and felt markers work well for group brainstorming.

4. Combine group discussion with individual work time. By working alone, each member of the team can develop and prototype a range of potential solutions. When working together, the group can discuss the strengths and weaknesses in each solution, combine possibilities, and expand ideas.

5. When you reach an impasse, take a breather. Walk around the block, get a cup of coffee, or try some very loose, gestural drawing. Even a 10-minute break can provide fresh insight and reduce contention.

6. Check your ego at the door. Helping a colleague realize his or her grand design may be more important than realizing your personal idea.

7. Ask the introverts for their opinions. Sometimes, the people who talk the least have the most to say.

Here's a specific strategy. Get together with at least two other students. Friends from another section of the same course can be especially helpful. Then:

▮ Discuss the assignment, making sure you understand what it is really about.

▮ Spend 10 to 15 minutes on individual solutions and thumbnail sketches.

▮ Talk over the results, giving each person time to speak.

▮ Pass your ideas to each of your partners and get your partners' ideas in return.

▮ Expand the idea your partners started. Essentially, you will develop an alternative solution based on his or her initial idea. Then share the results.

▮ Review the assessment criteria for the assignment. Be sure your great idea actually solves the problem presented in the assignment!

▮ Retrieve your initial idea, and draw it one more time, based on everything the team has discussed.

Success Strategies

VIRGINIA CENTER FOR THE CREATIVE ARTS: DEVELOPING A CREATIVE COMMUNITY

Courtesy of VCCA

Suny Monk, Executive Director, VCCA

As described in its mission statement, "the Virginia Center for the Creative Arts is a year-round community that provides a supportive environment for superior national and international visual artists, writers and composers of all cultural and economic backgrounds, to pursue their creative works." Over a recent one-year period, VCCA hosted 341 Fellows (as the resident artists are called), including 110 sculptors, painters, photographers, and other visual artists. Residencies are generally two to six weeks in duration, and for a modest fee, each fellow is provided with studio space and a small bedroom.

VCCA is one of more than 200 artist residency programs in the United States. Each program has its own unique character. For example, the John Michael Kohler Arts Center encourages exploration of connections between art and industry, and Skowhegan School of Painting and Sculpture offers nine-week residencies that connect master artists with emerging artists. All require a rigorous application process.

Courtesy of Bernard Handzell

VCCA studio building

*A team of dedicated administrators makes it all work. We will hear from vari-
ous members of the team in the following interview, starting with Suny Monk, the
Executive Director.*

MS: Suny, what is your background?

SM: Both of my parents were teachers, and as a child I was surrounded by cul-
tural events, including plays, drawing lessons at the museum, piano lessons.
For my bachelor's degree, I attended a small liberal arts college, where I
majored in art and minored in music. I got my master's degree in art education
from Ohio University, with a concentration in ceramics.

MS: How did you become an arts administrator?

SM: During grad school, I began work as a resident advisor in a dorm. I gradu-
ally took on more responsibility, finally overseeing five dorms. So, at the age of
23, I realized I had good organizational skills and could handle the demands of
leadership.

I worked for 3 years in the public schools in Richmond, Virginia, then moved
on to an independent school. I now had more freedom to create innovative
programs, and by the time I left, 15 years later, I was head of a growing school
with a thriving art program. At the age of 50, I decided to expand my adminis-
trative skills. I worked with a career development consultant, then accepted the
position directing VCCA.

MS: What changes did you implement right away?

SM: Giving each staff member clear and appropriate responsibility was an essential first step. During my interview, I had emphasized the importance of collaboration: VCCA is not "my" organization, it is an organization that is built by every member of the team. Let me introduce three of my colleagues.

MS: Craig Pleasants, what do you do as VCCA Program Director?

CP: As Program Director, my focus is on developing and implementing programs that further the mission of supporting the work of individual artists. In addition to developing grants to support artists from particular geographic regions, I have also created programs that bring different types of artists together for collaboration or discussion.

MS: Amy Allen, you are the Communications Director. Can you describe your background and responsibilities?

AA: I came to VCCA on a creative writing fellowship in 2001, then became resident artist in 2002, which involved working 15 hours a week in the office and offering after-hours assistance to artists. It soon became a full-time position. Now, as Communications Director, I am responsible for all publications, publicity, and a myriad of associated communications tasks.

In terms of publicizing the VCCA, the entire staff is focused on that task 24–7. For my part, I find opportunities to pitch news stories to local and national news outlets. Much of my time is also spent generating materials that support programming and development projects that are designed to increase awareness of the VCCA, its offerings, potential, and impact.

MS: Sheila Pleasants, you are the Director of Artists' Services. How are Fellows selected by VCCA?

SP: Visual artists send two sets of six slides, a vitae, reference letters, and an application form that includes a brief description of the work proposed for the residency. We have a panel of about 50 reviewers from various disciplines, and we send each application to two reviewers who are well versed in the applicant's field.

The applications are ranked, largely on the basis of the strength of the slides. Then, scheduling begins. New applicants with the highest rankings are placed first, then we work our way down the list. It is highly competitive, and I advise all applicants to be flexible. If you list only two possible weeks, right in the middle of our busiest time, you greatly limit your chances.

MS: For all of you, it seems that an enormous amount of work is done in the service of the creativity of others. What do you get out your VCCA work?

SP: I love making the pieces fit and seeing the fellows flourish. VCCA gives artists time to be their true selves. Freed of day-to-day responsibilities, they are amazingly productive. We have a library of books written by poets and novelists and CDs recorded by composers. And artworks donated by fellows fill the buildings and grounds.

SM: When I face a steep administrative hill, I think about the impact we have on artists' lives. The fellows just love VCCA; some are in tears when they leave. Too many people are counting on us; we can't just quit. When faced with a seemingly impossible task, we simply must find our way to a solution.

UNIT 14

Researching Your Major

If you're not in the jungle, you're not going to know the tiger.

Tom Kelley, CEO, IDEO

Selecting a major is the next step in your ladder-building process. This often occurs in the second semester of the first year. Each department or school presents this information in its own way, so get details from your school. Learn as much as possible. If you have to change majors, you may need to take a *lot* of additional coursework. The following checklist can help you organize basic information.

Potential Major #1

I'm attracted to this major because _____

I'm apprehensive about this major because _____

Skills I will need for success in this major _____

Potential careers _____

Getting more info _____

Contact people _____

Potential Major #2

I'm attracted to this major because _____

I'm apprehensive about this major because _____

Skills I will need for success in this major _____

Potential careers _____

Getting more info _____

Contact people _____

In some programs, you may be asked to do more extensive research on potential majors, such as compiling a collection of magazine articles or writing a paper. Books, magazines, and especially websites for professional organizations are excellent sources of basic information. (For your convenience, a basic list of websites is provided at the end of this book.) And, to gain a personal perspective about a potential major, you can also interview artists and designers at your school or within your community. Most successful people love to talk about their professional accomplishments, and you may discover a wonderful mentor or role model in the process.

Four examples of research into potential majors follow. The first begins with a brief quote from a single printmaker, then focuses on the field itself. A description of the work of three sculptors serves as a springboard into the second essay. The third essay developed from an interview with an artist and offers a description of her work, and the final example presents an extended interview.

Example #1: **PRINTMAKING**

If you want to become a printmaker, it helps if you like wrestling alligators.

Michael Barnes, lithographer

Printmaking is arguably the most technical of the two-dimensional art processes. Rather than drawing or painting directly on a sheet of paper, the printmaker creates the image on one surface, then transfers it to another surface, such as paper or fabric. Development of the master block, screen, or plate can be labor-intensive, and the printing process itself requires substantial skill.

The four major print processes are relief, intaglio (including etching and engraving), serigraphy (or silkscreen), and lithography. In the first three cases, a physical separation is created between the image and non-image areas. In lithography, a chemical separation is created, using nitric acid and gum arabic.

Images may evolve over many weeks. The printmaker often pulls a dozen or more trial proofs, seeking just the right combination textures, shapes, and values. The process becomes even more complex when color is used. Separate plates or blocks are created for each color, then carefully combined to create the final image.

Contemporary Printmaking

In a sense, printmaking sits right at the junction between art and design. Illustrators and graphic designers can use printmaking to add distinctive power to posters or brochures, and fine artists use printmaking to express personal insights and emotions.

As with all areas in art and design, contemporary printmaking is strongly influenced by popular culture and digital media. Enrique Chagoya combines images from advertising with archeological imagery to comment on the collision of the past and present in Mexico and the United States. Melissa Harshman uses photographic sources and clip art to explore childhood memories. Tanja Softic uses botanical and architectural imagery to suggest the passage of time. Each artist combines imagery with insight to make a personal statement.

Studying Printmaking

Printmaking majors generally develop the following:

❚ *Patience.* Printmakers must sustain concentration over weeks of work.

❚ *Appreciation of technical processes.* In a sense, printmaking is both an art and a science. For example, the six basic steps needed to create a lithograph can seem pretty confusing at first. The printmaker must learn to think through the process—using the various techniques to increase rather than inhibit visual thinking.

❚ *Interest in variables.* Once a block, plate, screen, or stone is created, you can create many variations on the basic image by variations in inking. As a result, you can try out many ideas without destroying the original image.

❚ *A sense of community.* Many types of printmaking must be done in a shared printshop. The presses are too heavy to move and too expensive to own individually. As a result, printmakers tend to help each other and often work collaboratively.

❚ *Terrific-looking artwork.* In many ways, printmaking is like industrial-strength drawing. An etching can resemble a pen-and-ink drawing, and a lithograph can resemble a drawing in conte or charcoal. The blacks are blacker and the embossment created through etching adds a distinctive texture.

❚ *A great art collection.* Because the multiple images are produced every time you pull an edition, it is easy to trade with others in your class.

Careers in Printmaking

Independent Artist.
Once the master blocks, screens, or plates are created, multiple images can be printed. Each print is equally original because each has been pulled from the same master surface. This simple process of multiplication provides the independent artist with more work to show and sell. Many collectors love the rich imagery and lively ideas developed by contemporary printmakers, and prints are widely shown in galleries and museums.

Master Printer.
Painters, sculptors, and other artists are often attracted to printmaking, but may lack the equipment and technical skill needed to produce their best work. To solve this problem, they hire a master printer, who collaborates in the development of the print and publishes the edition. Becoming a master printer generally takes at least two years of study, either in an apprenticeship situation or in a training program at a major printshop, such as the Tamarind Institute of Lithography.

Arts Administrator.
A surprising number of printmakers make their living as arts administrators. The perseverance learned in the printshop is of great value when fundraising, grant writing, or overseeing the work of others.

Courtesy of Kristen Kleckler

Sculpture by Kristen Kleckler

Example #2: **SCULPTURE**

Co-written by Mary Stewart and Jessica Witte

Across the country, sculpture studios hum with activity.

Kristen Kleckler buffs a large plastic children's slide. Retrieved from a curb-side on garbage day, she has altered its form and is now using a power buffer to clean off the remaining scuffmarks. After it is cleaned, Kristen will place the slide on a picket fence enclosure she has bolted together. Several spikes from the fence will stick through the bottom of the slide, altering its appearance and shifting its meaning from the playful to the sinister.

Michael Zasadny saws six steel rods to specific lengths, then feeds each piece into a bending apparatus, curling the metal into an even curve. He adds a long strip of flat steel and curls it into a hoop. Arming himself with a welding jacket and helmet, he welds the curved pieces onto the hoop, creating a metal

basket. Ultimately, this basket will be attached to a steel arm riveted onto a leather jacket. This jacket and attached basket will become props for a performance Michael has planned.

Todd Slaughter creates a floating landscape using enormous hat-like forms that are completely covered with finely ground paprika. They will be installed over the viewer's head, like a magical image from a dream.

Contemporary Sculpture

An incredible range of materials and processes can be used to produce sculptural objects. Traditional materials include wood, metal, fibers, clay, glass, and plastics; folding, casting, carving, weaving, and stamping are just a few of the construction methods. Contemporary materials include felt, spools of thread, crushed automobiles, ice, fire, charred wood, pools of oil, and chunks of lard. Each material has both limitations and possibilities, some of which are documented and some are only learned by experimentation.

Studying Sculpture

As a sculpture student, you will need the following:

▎ *Good time management.* Sculpture is very labor-intensive. To get the work done, you must schedule your time well ahead of the deadline. Some chemical reactions, like fiberglass resin curing times, will dictate when you can add another layer of materials. Leaving paint to dry overnight, letting castings set completely, and letting the glue dry before sanding are all instances where you cannot hurry the process without destroying the artwork.

▎ *Tenacity.* Many processes used for sculpture are physically demanding. Even using power tools can be exhausting if you are working for hours on end. Remaining focused and sticking to your goals requires great determination.

▎ *Resourcefulness.* A wide range of methods and materials are now available to the sculptor. You will often need to consult websites and manuals and ask product representatives, designers, and other sculptors for assistance in completing your project. By scouring hardware stores, industrial suppliers, and even junk shops, you can often create a more affordable, less toxic, or less labor-intensive artwork.

▎ *An ability to plan complex structures.* Careful planning can help you determine the most cost-effective and least labor-intensive construction strategy.

▎ *An understanding of physical laws, such as gravity.* Especially if you are working on public commissions, you will need to consider the stability of your structure. Will it remain stable, even when children climb on it?

▎ *An ability to budget.* Because of the high cost of some materials, creating a budget and using less expensive alternatives is a necessity for most students. As a professional, remaining aware of the cost of materials and your labor will allow you to present a client with a budget that is realistic and fair to both of you.

▎ *A sense of community.* You will need the help of others to create and move large-scale artworks. Reciprocating when others are in need will provide you with helping hands when you need them.

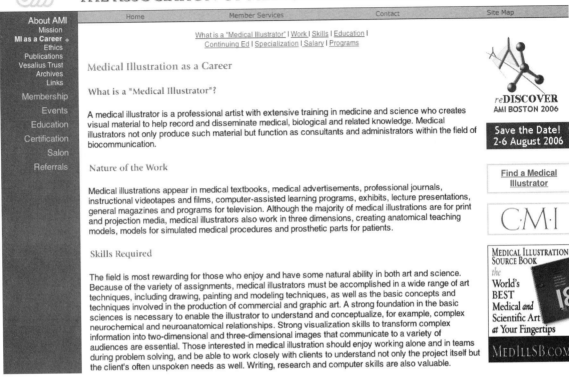

THE ASSOCIATION OF MEDICAL ILLUSTRATORS

| Home | Member Services | Contact | Site Map |

About AMI
Mission
MI as a Career ◆
Ethics
Publications
Vesalius Trust
Archives
Links

Membership

Events

Education

Certification

Salon

Referrals

What is a "Medical Illustrator" I Work I Skills I Education I
Continuing Ed I Specialization I Salary I Programs

Medical Illustration as a Career

What is a "Medical Illustrator"?

A medical illustrator is a professional artist with extensive training in medicine and science who creates visual material to help record and disseminate medical, biological and related knowledge. Medical illustrators not only produce such material but function as consultants and administrators within the field of biocommunication.

Nature of the Work

Medical illustrations appear in medical textbooks, medical advertisements, professional journals, instructional videotapes and films, computer-assisted learning programs, exhibits, lecture presentations, general magazines and programs for television. Although the majority of medical illustrations are for print and projection media, medical illustrators also work in three dimensions, creating anatomical teaching models, models for simulated medical procedures and prosthetic parts for patients.

Skills Required

The field is most rewarding for those who enjoy and have some natural ability in both art and science. Because of the variety of assignments, medical illustrators must be accomplished in a wide range of art techniques, including drawing, painting and modeling techniques, as well as the basic concepts and techniques involved in the production of commercial and graphic art. A strong foundation in the basic sciences is necessary to enable the illustrator to understand and conceptualize, for example, complex neurochemical and neuroanatomical relationships. Strong visualization skills to transform complex information into two-dimensional and three-dimensional images that communicate to a variety of audiences are essential. Those interested in medical illustration should enjoy working alone and in teams during problem solving, and be able to work closely with clients to understand not only the project itself but the client's often unspoken needs as well. Writing, research and computer skills are also valuable.

reDISCOVER
AMI BOSTON 2006

Save the Date!
2-6 August 2006

Find a Medical Illustrator

C·M·I

MEDICAL ILLUSTRATION SOURCE BOOK
the
World's BEST Medical *and* Scientific Art at Your Fingertips
MEDILLSB.COM

Website for The Association of Medical Illustrators, http://ami.org/aboutami/career.php. Accessed October 21, 2005.

Example #3: **MEDICAL ILLUSTRATION AS A CAREER**

Organizations' websites are excellent resources for learning about careers and for preparing for interviews. A page from the Association of Medical Illustrators website (http://www.ami.org) is shown here. This website provided the background information for an interview with Pat Thomas, the organization's president.

Case Study: Pat Thomas, Trial Graphics Specialist

Pat Thomas specializes in medical illustrations for presentation in court cases. Her clients include both the prosecution and the defense in medical malpractice cases, as well as litigants in personal injury cases. In all cases, she must explain complex scientific concepts through illustration. "I function as a translator," Ms. Thomas says. "My clients are often foreign-trained doctors. They can explain a medical problem to another doctor, but may not be able to describe it to the layperson on a jury. By combining my artistic talents with my knowledge of science, I make complex information visible."

Pat Thomas

Thomas became interested in medical illustration at the age of 16. She had been interested in art and science from an early age and when a biology teacher recommended medical illustration as a way to combine the two, Ms. Thomas was immediately intrigued. She began work on her five-year bachelor of science degree in 1973, and during her senior year, landed a job making slide and tape programs for the School of Medicine at University of Illinois.

After 20 years of work in various institutional settings, Ms. Thomas developed her own business, which she now runs from her personal studio. A trial graphics agency locates clients, and prints and ships the illustrations she makes. Ms. Thomas notes the following essentials for a professional in this field. "In addition to knowledge of both art and science, a medical illustrator must have a good rapport with clients, and an excellent understanding of the audience. Dependability is essential. If my work is not done properly by the date due, the entire court case will be weakened."

Example #4: **INDUSTRIAL DESIGNER AS ACTIVIST**

Manny Hernandez: Design Activism

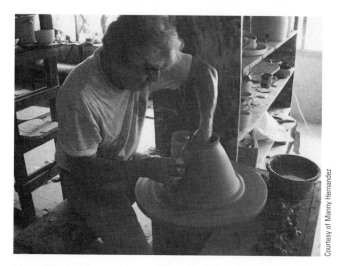

Courtesy of Manny Hernandez

Manny Hernandez

MS: How did you select a college, and why did you major in industrial design?

MH: Going to college at all was a major challenge for me. My parents migrated from Mexico, and my six siblings and I are the first generation in this country. My oldest brother, David, was the one most interested in education. After a tour of duty in World War II, he spent eight years in a VA hospital battling tuberculosis. That gave him a lot of time to read. He became convinced that education was the key to the future and insisted I attend college.

The University of Illinois catalog featured a picture of a student modeling a car out of clay. I had always tinkered with hot rods and was accustomed to making something from nothing, so I was immediately intrigued. That led me to major in industrial design. After my success in college, all of my brothers followed suit, which transformed my family.

MS: Tell me about your industrial design career.

MH: I worked as a professional designer for 12 years, primarily designing stereos, radios, and other appliances for Zenith, GE, and other manufacturers.

MS: Why did you decide to change careers?

MH: Boredom. It became pretty repetitive after a while. I wanted something more challenging and more flexible. I returned to school at Northern Illinois University and received my MFA in ceramics in 1980.

MS: How did your ID background influence your work as a ceramicist?

MH: Actually, I combined my two interests from the very beginning. My graduate level research was determined by the global gas crisis in 1973. I became interested in using alternative fuels (such as agricultural waste) to fire a kiln.

To get this to work, I developed an alternative fuel injector system (AFIS) made up of a sieve, a hopper, a vacuum/blower unit, and a simple motor. It works by putting sawdust into the sieving box that is agitated by a connecting rod that is then connected to a crankshaft. This system, which is an essential component of the "Mani" kiln I later designed, is widely used in developing countries.

MS: How did you get involved in Potters for Peace (PFP)?

MH: In 1992, I went to a National Conference on Education for the Ceramic Arts (NCECA) meeting. A slide presentation by Ron Rivera, the PFP representative in Central America was especially interesting. In it, he showed two women potters putting handfuls of sawdust into a hopper, which is a very tedious job, considering that a firing can last three to four hours.

The next day, as I was checking out from the hotel, I noticed that Ron was right behind me in line. I told him that I fired my kiln with sawdust, but used a mechanized system. His jaw dropped. He insisted that my technical assistance was needed in Nicaragua right away. I have been with PFP for 12 years now, working in nine developing countries on three continents. I also serve on the board of directors.

MS: Please describe a typical PFP project.

MH: The World Health Organization has estimated that 2.2 million people in developing countries die each year from diarrheal disease. The vast majority are children under the age of five.

Working with a PFP team, I train potters in Third World countries to make ceramic water filters. These filters are made from a combination of locally available clay and sawdust or other combustible agricultural waste. The filters can be hand thrown on a potter's wheel or mold made using a 12-ton hydraulic truck jack. During the firing process, the sawdust is burned out, creating minute pores in the clay. After firing, the filters are given a coating with colloidal silver, which kills the pathogens in the water. Contaminated water is poured into the top; clean water drips out the bottom.

MS: What is the budget and schedule for these projects?

MH: Generally, we work on a very tight schedule and a budget of less than $10,000. For example, in a 2001 trip to Cambodia, we had a month to

▮ find and lease land so that we can build a facility;

▮ choose a reliable contractor to build the overall structure housing the facility;

▮ estimate the quantity and cost of all the materials needed for facility construction as well as ceramic filter production and have them delivered to the site;

▮ construct a "Mani" kiln and a shelter to protect it from the elements;

▌ test fire the kiln;

▌ drill a well or clean an existing well to supply the water;

▌ install a treadle pump to supply running water;

▌ build a latrine.

MS: How on earth do you get it all done?!

MH: The villagers have an incredible work ethic. Men, women, and children all pitch in, working through a downpour if necessary. And, they are wonderfully inventive. In Cambodia, all our supplies, except for the sand, gravel, and stone, were hauled to the site on bicycles and trailers attached to small motorcycles.

MS: Most of us think of galleries or design firms when we envision ourselves as professional artists or designers. It seems that you have developed a completely different approach to your life in the arts. What have you gained, and what have you lost as a result?

MH: Well, I have lost time I might have spent with my family, but they understand the important need for what I am doing. Since 1992, I have traveled to work on projects in Cambodia, Cuba, Ecuador, El Salvador, Guatemala, Haiti, Honduras, Mayanmar, Iraq, Mexico, and Nicaragua. I often work on a project during Christmas or other holidays.

On the other hand, I have certainly gained a lot of compassion for the poor and a lot of respect for the women who dominate the pottery business in these countries. And, I have gained a new perspective on art and design. In my line of work, art and design can save lives.

WRITING A GREAT INTERVIEW: A TOP-TEN LIST OF ACTIONS TO TAKE

Here is some practical advice on conducting and writing an interview.

1. *Prepare yourself.* Using the Internet and magazines or other library sources, read as much as you can on the person you are interviewing. Based on your research, come up with a list of at least 20 questions, such as the following:

▌ What is it about sculpture that you find most intriguing?

▌ What is it about sculpture that you find most challenging?

▌ When did you decide to pursue art professionally?

▌ What are the sources of your ideas?

▌ How did you start your current project?

▌ What ideas did you discard along the way? Why?

▌ What interest do you have outside of your art practice?

▌ How do these interests influence your studio work?

▌ What was the most difficult project you have ever undertaken, and what was it that made it so difficult?

▌ How did you resolve the problems you encountered?

- ▮ What is your criteria for excellence?
- ▮ When I finish college, I will have to make a transition into the professional world. Any advice?

2. *Set the stage for a productive interview.* Find a quiet place to talk, preferably in the artist's studio or at a coffee shop. Let your subject know the purpose and extent of the interview you have planned. Bring at least two pens and, if appropriate, a recording device. Get permissions from your subject before you begin to record.

3. *Arrive early.* The person you are interviewing is giving you a gift of great value—his or her time and ideas. Be sure to handle this gift with care.

4. *Pay attention.* If you are interviewing people in their homes or studios, be sure to get a good look around and note what you see. The books they are reading, the music they enjoy, and artwork on the walls can tell you a lot about their travels, taste, and interests.

5. *Ask good follow-up questions.* Try to get the richest, most complete story possible.

6. *Listen carefully.* Don't rush your interviewee. Start by establishing a good rapport and a level of comfort. Talk very little about yourself. You are there to hear their story, not to tell your story. And, maintain eye contact. Take abbreviated notes looking down only occasionally so you can focus on your interviewee.

7. *Allow enough time.* If the interview goes well, it may go well beyond the scheduled time, and that last half hour may be the most compelling. Generally, 30 to 60 minutes are needed for an 800-word interview.

8. *Be accurate, and be inspired.* Get exact spelling of names and unfamiliar places, and be sure to quote your source accurately. However, don't try to transcribe the interview word for word—that will make your source sound like an idiot. For best results, combine summary comments with exact quotes.

9. *Before you leave, ask your source if there is anything further he or she wants to say.* Perhaps the interviewee is burning to tell you something terrific, but you did not even think to ask that question.

10. *Follow up.* Write a rough draft as soon as possible. If you wait a week, your notes will dissolve into an incomprehensible blur. Don't leave without getting a contact number or e-mail address and a good time to call with follow-up questions. Finally, it is usually appropriate to send your interviewee a thank-you note, along with a final copy of the interview.

Use this space to brainstorm your own interview questions:

UNIT 15

Self-Reflection

Every exit is an entry somewhere else.

Tom Stoppard

Term's end is fast approaching. As you develop plans for the next semester, refer back to your goals and reflect on your progress.

List the three most valuable skills your learned this term:

List three skills you want to master next term:

List the three most valuable assignments you completed, and note how they contribute to your overall goals:

1. _____

2. _____

3. _____

In reviewing the entire term, what goals did you meet or exceed?

 If you have made substantial progress in your first semester, terrific! You are already well on your way to building a career ladder. If you feel that you mostly learned what NOT to do, congratulations! That is also valuable. In either case, in the following section, or in a more extended essay, consider your overall progress, and begin to make plans for next term.

In what areas do you want to improve your performance next term?

What specific actions can you take to improve your performance next term?

UNIT 16

Building a Career

It's like driving a car at night. You never see further than your headlights, but you can make the whole trip that way.

E. L. Doctorow

As you complete your first semester or your first year of college, begin to expand your timeframe and broaden your strategy. Using the same skills described in Units 5 and 6, begin to rough out a four-year plan. You don't need all of the details at this point; unexpected changes will occur no matter how carefully you plan. What you do need is an intended destination. Consider where you want to go after college, and what skills, knowledge, and experience your need to develop.

To get a better sense of the work ahead, re-read the interviews in Units 11, 12, 13, and 14, as well as our final interview, with Flux Design, on page 72. Note that many refer to internships and that Nathan Kanofsky and Heather Arak-Kanofsky used a semester abroad and an honor's project to build career skills. Most colleges and universities support internships, international programs, and honor's projects, so explore the possibilities at your school.

Then, use this final workbook page or another format of your own to begin building a broader career ladder. Make it erasable: You will need to modify it repeatedly as your ideas develop and your undergraduate education unfolds. Good luck!

First Year

Fall Courses	Spring Courses	Summer Courses or Work Experience
_____	_____	_____
_____	_____	_____
_____	_____	_____
_____	_____	_____
_____	_____	_____
_____	_____	_____

Career-Building Goals: _____

Second Year

Fall Courses	Spring Courses	Summer Courses or Work Experience
_____	_____	_____
_____	_____	_____
_____	_____	_____
_____	_____	_____
_____	_____	_____

Career-Building Goals: _____

Third Year

Fall Courses Spring Courses Summer Courses
or Work Experience

_____ _____ _____

_____ _____ _____

_____ _____ _____

_____ _____ _____

_____ _____ _____

Career-Building Goals: _____

Fourth Year

Fall Courses Spring Courses Summer Courses
or Work Experience

_____ _____ _____

_____ _____ _____

_____ _____ _____

_____ _____ _____

_____ _____ _____

Career-Building Goals: _____

Success Strategies ▬▬

FLUX DESIGN:
BUILDING A CAREER FROM THE GROUND UP

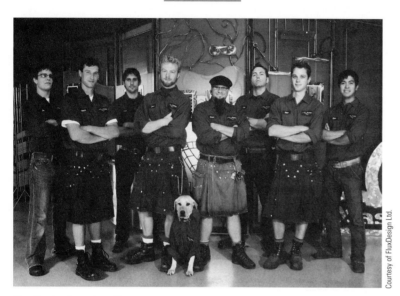

Flux Design team in uniforms

Flux Design is a design company and all-purpose think-tank located in Milwaukee, Wisconsin. Begun in 2000 by Milwaukee Institute of Art and Design (MIAD) graduates Jeremy Shamrowicz and Jesse Meyer, Flux produces everything from custom-designed staircases and room interiors to furniture, sculpture, and lighting systems. Three Flux designs were recently selected for inclusion in 100 of the World's Best Bars, published by Images Publishing Group, of Melbourne, Australia.

It all began with an empty shell in a bombed out build-ing, two sculpture majors, and a pile of junk.

Shamrowicz, Meyer, and a network of Flux friends literally camped indoors while constructing the interior for Gallery 326, which they installed in a historic warehouse space not far from MIAD. They also began building furniture to show at the gallery's opening events. Restricted by a shoestring budget, they scavenged junkyards and salvaged scraps of wood and bits of metal from demolished buildings.

Flux now works in media as varied as concrete, glass, wood, plastic, stone and steel. The 12 designers on the team are inspired by a wide range of influences, from contemporary Japanese minimalism and the work of Frank Lloyd Wright to the futuristic special effects found in movies such as Dune, Blade Runner, *and* Star Wars. *My interview with co-founder Jeremy Shamrowicz follows.*

MS: How did it all start?

JS: Art, design, building, creativity, making stuff—I've been doing that my entire life. I don't remember the day when I woke up and said, "Hey, I'm an artist today!" I do know it all started with blocks, Legos, drawings, and making little dams in the creek. According to my business partner Jesse Meyer, curiosity leads to creativity.

MS: Tell me about your initial experiences in art school.

JS: I grew up on a farm near Oshkosh, Wisconsin. I have a very hard time with reading and writing, and hadn't even planned on going to college. I have to thank my friends for encouraging me to send my portfolio to MIAD and to arrange an interview. I got in, and even though resources were tight, my par-

ents offered their whole-hearted support. I could see that it was a great opportunity, and was determined to make the most of it.

From day one, I felt both welcomed and challenged. In an art department or school, the students generally represent the top 10 percent of young artists in the country. In the convocation at the beginning of the year, I started looking around the room, wondering which students were the best of the best. I wasn't just seeking competition—it was more about understanding the whole learning environment. In art school or college, you can learn a lot from the people around you. I quickly realized that the more I gave to others, the more I would get in return.

MS: You entered as an illustration major, then made that into a minor and double-majored in sculpture and industrial design instead. How and why did that happen?

JS: I had been doing airbrush in high school, and when I entered I was totally committed to illustration. My foundations classes gave me more experience with three-dimensional methods and materials. Finally, I realized that I just wanted to make stuff. I liked playing around with each material, experimenting with its strength, weight, response to lighting, and so on. Use of materials was emphasized in both sculpture and industrial design, and I liked working with fine art and design equally. That led to the double major.

MS: How did you start making furniture?

JS: Initially, I just wanted to make a table out of concrete and steel, two man-made materials that have a very raw, natural quality. It didn't quite fit in either sculpture or industrial design, so I took an independent study with Frank Lukasavitz, who was the shop technician.

Boy, did he make me work. He made me go to three different types of furniture companies to investigate form, function, production, and marketing. I had to study the furniture and write a report on each person I interviewed. Next, I wrote a paper about the piece I wanted to build. I really just wanted to make stuff, and at this point I thought, well, this isn't gonna be as much fun as I thought it would be! Finally, he drilled me on balance, proportion, and scale. From this experience, I really learned about the complexity of the process and the importance of research.

I then made a series of tables, stuck them in a hallway at school, and without planning to, sold them within two weeks. This was the career springboard I needed. I used the money to buy more materials. And, realizing that I would need to get accustomed to talking to clients, I started wearing a shirt and tie to critiques.

MS: Another major aspect of Flux production is interior design. How did you gain experience in this area?

JS: MIAD decided to develop a student union building in an old tavern across the street from the school. Rather than just fill it with second-hand furniture, the student government proposed that students design and build the space. The interior architecture professor used it as a class project, and by the end of the term, presented a whole range of great ideas. To come in on time and

within budget, I realized that the project would have to be done by students with strong construction experience. I was asked to serve as project manager, and enlisted the help of my Flux Design partner Jesse, with three other students rounding out the crew. We made our share of mistakes, but by working 14-hour days, seven days a week, we got the job done.

MS: It seems that Flux Design really grew out of the experiences that you, Jesse, and the gang had at MIAD.

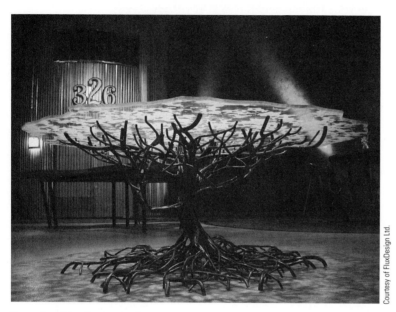

Example of Flux Design furniture

Courtesy of FluxDesign Ltd.

JS: Yes, and also from our work developing Gallery 326. Over a five-year period, we transformed a very raw warehouse space into a successful gallery. On average, over two thousand people would attend our opening parties, that last year. Then the lease ran out, and we moved to our current space.

MS: Tell me a bit about the Flux dynamic. What role do you and Jesse play? How are new team members chosen?

JS: Well, I'm the first contact person, a salesman of sorts. I focus on listening to our clients and determining what they need to have done. From there, I work with our management team and our design team to bring the client's vision to life. Jesse is more of an engineer. He focuses on maintaining the highest quality possible while using the most efficient fabrication method. He also has to work with the management team to coordinate schedules and complete installations.

Our team is comprised of hands-on people. Many of our earliest and longest-lasting crewmembers were chosen because they had diverse skills and were interested in learning new production methods. Sculptors and industrial designers predominate, but we've also welcomed printmakers, illustrators, graphic designers, and even filmmakers to the team.

MS: Your career seems to have evolved from a series of experiences. You didn't follow a predetermined path; instead, you and your Flux Design partners made your own path. What advice can you give to my students?

JS: Realize that art isn't only about production. It is also about the passion you have within, whether it is in your heart or your head. If you are passionate enough and willing to work, you will find a way to create.

Website
Sampler

ART EDUCATION LINKS

National Art Educators' Association http://www.naea-reston.org
Arts Education Partnership http://www.aep-arts.org/
Kennedy Center's ArtsEdge http://artsedge.kennedy-center.org/

ANIMATION LINKS

Atom Films www.atomfilms.com/af/animation/
Animation Artist www.animationartist.com/index.jsp
Animation Meat www.animationmeat.com
Animation Show www.animationshow.com
Pixar www.pixar.com/index.html

ART HISTORY AND MUSEUM LINKS

Art History Network (Art History, Archeology, and Architecture)
 http://www.arthistory.net/
Mother of All Art History Links Pages
 http://www.art-design.umich.edu/mother/
Museums and Art Galleries on the Web http://bertc.com/gallery.htm
Smithsonian American Art Museum
 http://americanart.si.edu/search/search_artworks.cfm
Museums and Art History
 http://www.msstate.edu/Fineart_Online/art-resources/museums.html
Art History Resources, Arizona State University Library
 http://www.asu.edu/lib/hayden/ref/art/arthist.html
Art Museum.Net: Multimedia http://www.artmuseum.net/w2vr/contents.html
Art 21: Art in the 21st Century http://www.pbs.org/art21/
Egg http://www.pbs.org/wnet/egg/index.html

New York Foundation for the Arts (includes section on artists' interviews)
http://www.nyfa.org/

The Museum of Contemporary Art, Sydney Australia http://www.mca.com.au/

New Museum of Contemporary Art http://www.newmuseum.org/

Massachusetts Museum of Contemporary Art
http://www.massmoca.org/index.html

Soap Factory www.soapfactory.org/

CERAMICS LINKS

Ceramics Today http://www.ceramicstoday.com/

Ceramics Monthly www.ceramicsmonthly.org/

Critical Ceramics: Topics in Contemporary Ceramic Art
http://criticalceramics.org/

The National Council on Education for the Ceramic Arts http://www.nceca.net/

FIBERS LINKS

Fiberscene http://www.fiberscene.com/

Textile Society of America http://www.textilesociety.org/about_about.htm

Surface Design Association http://www.surfacedesign.org/about.asp

European Textile Network http://www.etn-net.org/

Friends of Fiber Arts International
http://206.204.3.133/dir_nii/nii_dat_fiber.html

DESIGN LINKS

American Institute of Graphic Arts http://www.aiga.org/

The Chartered Society of Designers http://www.csd.org.uk/

Design Council www.design-council.org.uk/

Design Addict http://www.designaddict.com/

Industrial Design Society of America http://new.idsa.org/index.htm

International Council of Societies of Industrial Design http://www.icsid.org/

Web Page Design for Designers http://www.wpdfd.com/

ILLUSTRATION LINKS

The Association of Illustrators http://www.theaoi.com

Society of Illustrators http://www.societyillustrators.org/

Society of Children's Book Writers and Illustrators http://www.scbwi.org/

The Association of Medical Illustrators http://medical-illustrators.org/

METALSMITHING/JEWELRY LINKS

The Society of North American Goldsmiths http://www.snagmetalsmith.org/

Society for Contemporary Craft
http://www.contemporarycraft.org/current.html (Also a great general crafts reference)

Metalcyberspace www.metalcyberspace.com/

NEW MEDIA LINKS (VIDEO, INSTALLATION, PERFORMANCE)

Aurora Pictureshow http://www.aurorapictureshow.org/

Post Video Art http://www.post-videoart.com/

Video Data Bank http://www.vdb.org/

Mattress Factory http://www.mattress.org/

63 Manually Selected Installation Art Resources
http://www.cbel.com/installation_art/

Franklin Furnace Alums http://www.franklinfurnace.org/

Live Art Archive http://art.ntu.ac.uk/liveart/index.htm

The Kitchen, Resources, Video clips http://www.thekitchen.org/

Crossfade: Sound travels on the Web http://crossfade.walkerart.org/

Locus Plus http://www.locusplus.org.uk/index2.html

PAINTING AND DRAWING LINKS

The Drawing Center http://www.drawingcenter.org/

About.com http://drawsketch.about.com/od/contemporaryart/

PHOTOGRAPHY LINKS

Museum of Contemporary Photography www.mocp.org/

Photographic Resource Center at Boston University
http://www.bu.edu/prc/online.htm

Canadian Museum of Contemporary Photography http://cmcp.gallery.ca/

PRINTMAKING LINKS

Print Council of America http://www.printcouncil.org/

Mid-America Print Council homepages.ius.edu/special/mapc/MAPC.html

Prints Northwest www.printartsnw.org/

Maryland Printmakers www.marylandprintmakers.org

Center for Contemporary Printmaking http://www.contemprints.org/

Southern Graphics Council http://www.southerngraphicscouncil.org

SCULPTURE LINKS

The Contemporary Sculptors Association Inc Australia
 http://www.sculptors.org.au/

International Sculpture Center http://www.sculpture.org/

Navy Pier Walk http://www.pierwalk.org

Recommended Reading

ELEMENTS AND PRINCIPLES OF DESIGN

Arthur Asa Berger. *Seeing is Believing: An Introduction to Visual Communication,* 2nd edition. Mountain View, CA: Mayfield,1998.

Frank Cheathan, Jane Hart Cheathan, and Sheryl A. Haler. *Design Concepts and Applications.* Englewood Cliffs, NJ: Prentice-Hall, 1983.

Frank Ching. *Architecture: Form, Space, and Order,* 2nd edition. New York: Van Nostrand Reinhold, 1996.

Gail Greet Hannah. *Elements of Design: Rowena Reed Kostellow and the Structure of Visual Relationships.* New York: Princeton Architectural Press, 2002.

Stephen D. Katz. *Film Directing, Shot by Shot: Visualizing from Concept to Screen.* Studio City, CA: Michael Wiese Productions, 1991.

David A. Lauer and Stephan Pentak. *Design Basics,* 6th edition. Belmont, CA: Thomson Learning, 2005.

Scott McCloud. *Understanding Comics.* New York: HarperPerennial, 1994.

Mary Stewart. *Launching the Imagination: A Comprehensive Guide to Basic Design,* 2nd edition. New York: McGraw-Hill, 2006.

Wucius Wong. *Principles of Form and Design.* New York: Van Nostrand Reinhold, 1993.

Herbert Zettl. *Sight, Sound, Motion: Applied Media Aesthetics,* 4th edition. Belmont, CA: Wadsworth, 2005.

CONTEMPORARY ART AND DESIGN

John Beardsley. *Earthworks and Beyond: Contemporary Art in the Landscape.* New York: Abbeville Press, 1998.

Garth Clark. *The Artful Teapot.* New York: Watson-Guptill, 1981.

Mark Del Vecchio. *Postmodern Ceramics.* New York: Thames & Hudson, 2001.

Suzanne Frantz. *Contemporary Glass: A World Survey from the Corning Museum of Glass.* New York: Harry N. Abrams, 1989.

Roselee Goldberg. *Performance: Live Art Since 1960.* New York: Harry N. Abrams, 1998.

Janet Koplos. *Contemporary Japanese Sculpture.* New York: Abbeville Press, 1991.

Susan Grant Lewin. *One of a Kind: American Art Jewelry Today.* New York: Harry N. Abrams, 1994.

Nicolas de Oliveria, Nicola Oxley, and Michael Petry. *Installation Art.* Washington, DC: Smithsonian Institution Press, 1994.

CREATIVITY

David Bayles and Ted Orland. *Art & Fear: Observations on the Perils (and Rewards) of Artmaking.* Santa Barbara, CA: Capra Press, 1993.

John Briggs. *Fire in the Crucible: Understanding the Process of Creative Genius.* Grand Rapids, MI: Phanes Press, 2000.

Mihaly Csikszentmihalyi. *Creativity: Flow and the Psychology of Discovery and Invention.* New York: HarperCollins, 1996.

Howard Gardner. *Creating Minds: An Anatomy of Creativity Seen Through the Lives of Freud, Einstein, Picasso, Stravinsky, Eliot, Grapham, and Gandhi,* New York: Basic Books, 1993.

Malcolm Grear. *Inside/Outside: From the Basics to the Practice of Design.* New York: Van Nostrand Reinhold, 1993.

Tom Kelley. *The Art of Innovation: Lessons in Creativity from IDEO, America's Leading Design Firm.* New York: Currency Books, 2001.

Anne Lamott. *Bird by Bird: Some Instructions on Writing and Life.* New York: Anchor Books, 1998.

Twyla Tharp. *The Creative Habit: Learn It and Use It for Life.* New York: Simon & Schuster, 2003.

Roger Von Oech. *A Kick in the Seat of the Pants.* New York: Harper & Row, 1963.

Roger Von Oech. *A Whack on the Side of the Head.* New York: Harper & Row, 1986.

Doris B. Wallace and Howard E. Gruber (Editors). *Creative People at Work.* New York: Oxford University Press, 1989.

Judith and Richard Wilde. *Visual Literacy: A Conceptual Approach to Graphic Problem Solving.* New York: Watson-Guptil, 2000.

WRITING ABOUT ART

Sylvan Barnet. *A Short Guide to Writing about Art,* 6th edition. New York: Addison, Wesley, Longman, 2000.

Terry Barrett. *Criticizing Photographs: An Introduction to Understanding Images,* 2nd edition. Mountain View, CA: Mayfield, 1996.

Terry Barrett. *Interpreting Art: Reflecting, Wondering and Responding.* McGraw-Hill, New York, 2003.

Suzanne Hudson. *The Art of Writing About Art.* Belmont, CA: Thomson Learning, 2002.

Henry M. Sayre. *Writing About Art,* 4th edition. Upper Saddle River, NJ: Prentice-Hall, 2002.